landscapes camera craft

william cheung

AVA Publishing SA
Switzerland

Published by AVA Publishing SA
rue du Bugnon 7
CH-1299 Crans-près-Céligny
Switzerland
Tel: +41 78 600 5109
Email: enquiries@avabooks.ch

Distributed by Thames and Hudson (ex-North America)
181a High Holborn
London WC1V 7QX
United Kingdom
Tel: +44 20 7845 5000
Fax: +44 20 7845 5050
Email: sales@thameshudson.co.uk
www.thamesandhudson.com

Distributed by Sterling Publishing Co., Inc.
in USA
387 Park Avenue South
New York, NY 10016-8810
Tel: +1 212 532 7160
Fax: +1 212 213 2495
www.sterlingpub.com

in Canada
Sterling Publishing
c/o Canadian Manda Group
One Atlantic Avenue
Suite 105, Toronto
Ontario M6K 3E7

English Language Support Office
AVA Publishing (UK) Ltd,
Tel: +44 1903 204 455
Email: enquiries@avabooks.co.uk

Copyright © AVA Publishing SA 2002

ISBN 2-88479-006-3

10 9 8 7 6 5 4 3 2 1

Design and coordination by Kate Stephens

Production and separations by
AVA Book Production Pte. Ltd., Singapore
Tel: +65 6334 8173 Fax: +65 6334 0752
Email: production@avabooks.com.sg

Printed in China

landscapes

camera craft

william cheung

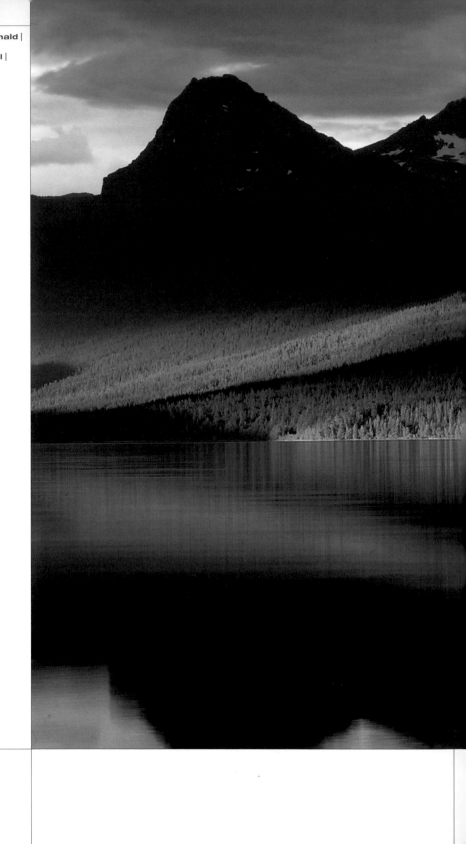

▶ Evening | Lake McDonald |
Glacier National Park |
Montana | USA | Tom Till |

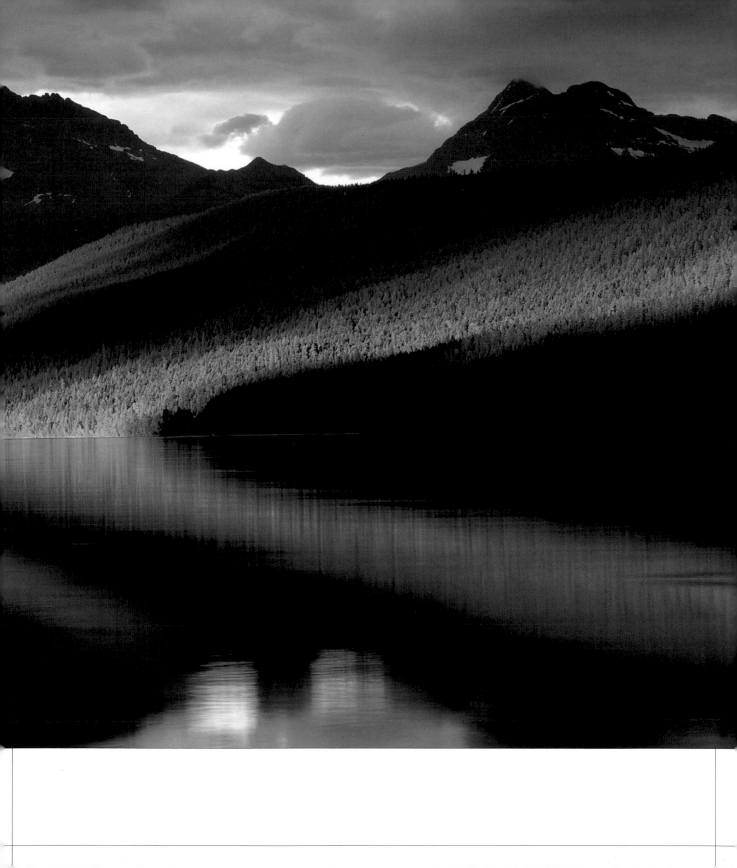

Landscape photography is a hugely popular subject for camera-owners everywhere. Whether it is a walk in the countryside or a holiday overseas, photographers love recording what nature has to offer. But it is also true to say that many photographers are disappointed with their pictures because they fail to encapsulate the sheer majesty of the scene that was in front of them at the time. In most cases, some simple technique, like taking a few steps to one side, can make the difference between a good shot and a great one.

The aim of this book is not only to inspire and encourage, but also to help photographers of all ability levels to take great scenic pictures – images that are truly memorable and have a sense of place.

To do this, we have compiled a collection of superb scenic pictures and spoken to the photographers who took them. What inspired them to take the shot in the first place, how did they use colour and composition for the best result, and how they overcame the technical problems were among the questions we put to them.

The resulting commentary is a revealing insight to how expert photographers think about the scenes in front of them and how they use their camera to take amazing scenic pictures. There is a blend of essential advice on framing and composition as well as the technical aspects of photography such as choosing the best lens, determining the correct exposure and loading the right film. There also is a tremendous variety of images taken in all sorts of lighting and weather conditions, and featuring many different photographic techniques.

For all landscape photographers, this book has inspiration and advice in large measure and will undoubtedly help you produce memorable pictures.

introduction william cheung

▶ Glowing Antelope |
Antelope Canyon | Northern
Arizona | USA | Alain Briot |

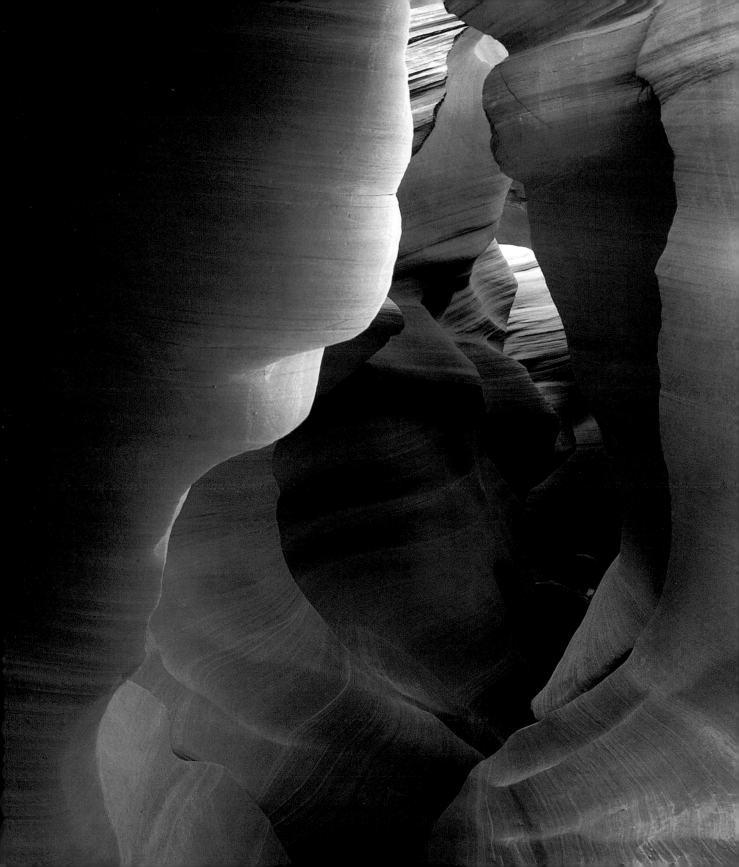

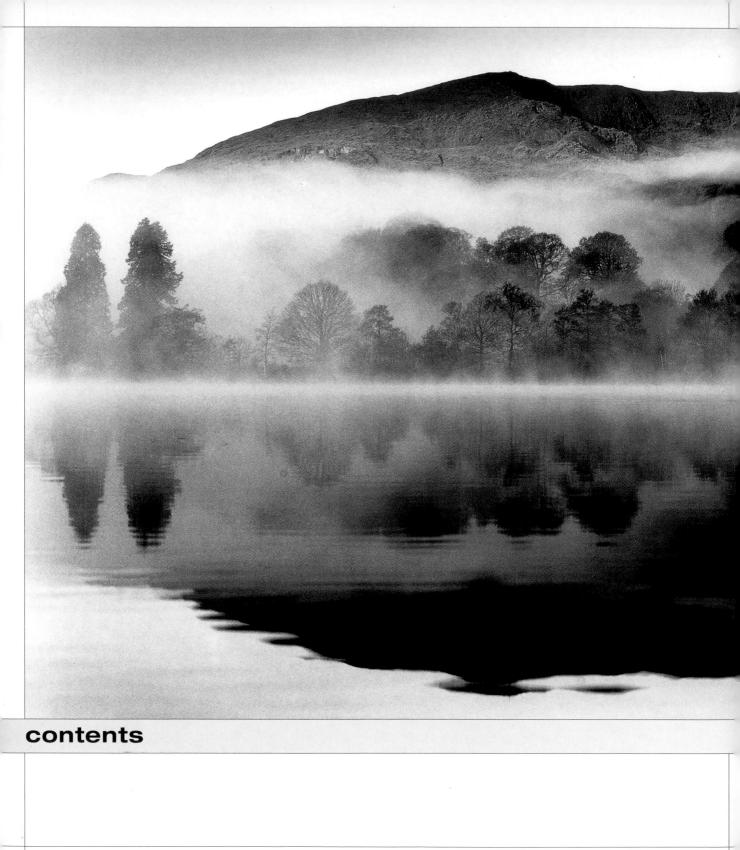

contents

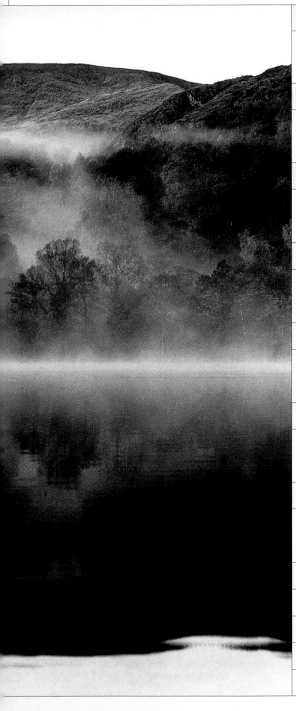

▲ Coniston Morning Mist |
Coniston Water | Lake District |
Cumbria | UK | Phil Handforth |

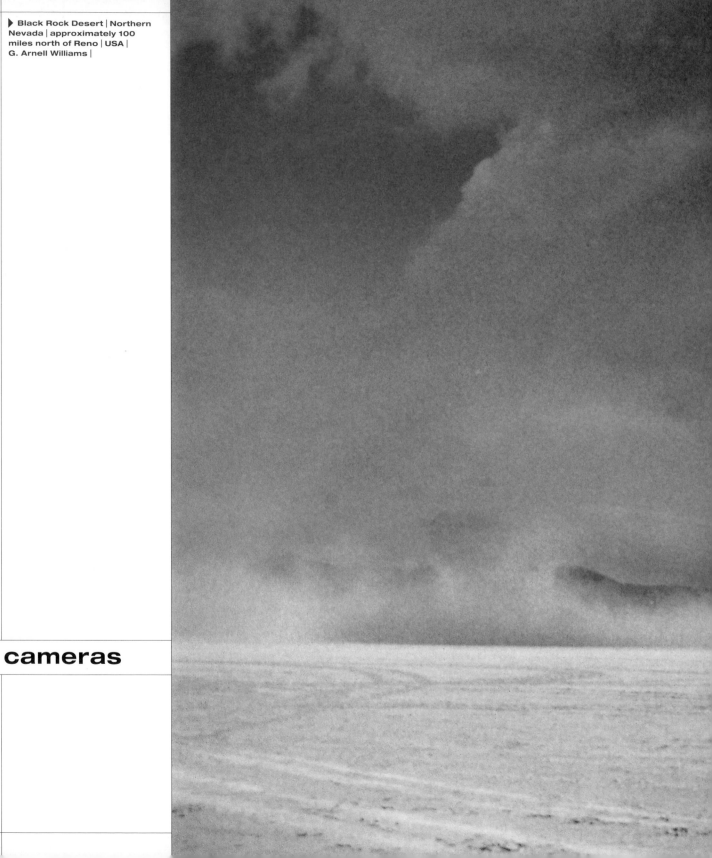

cameras

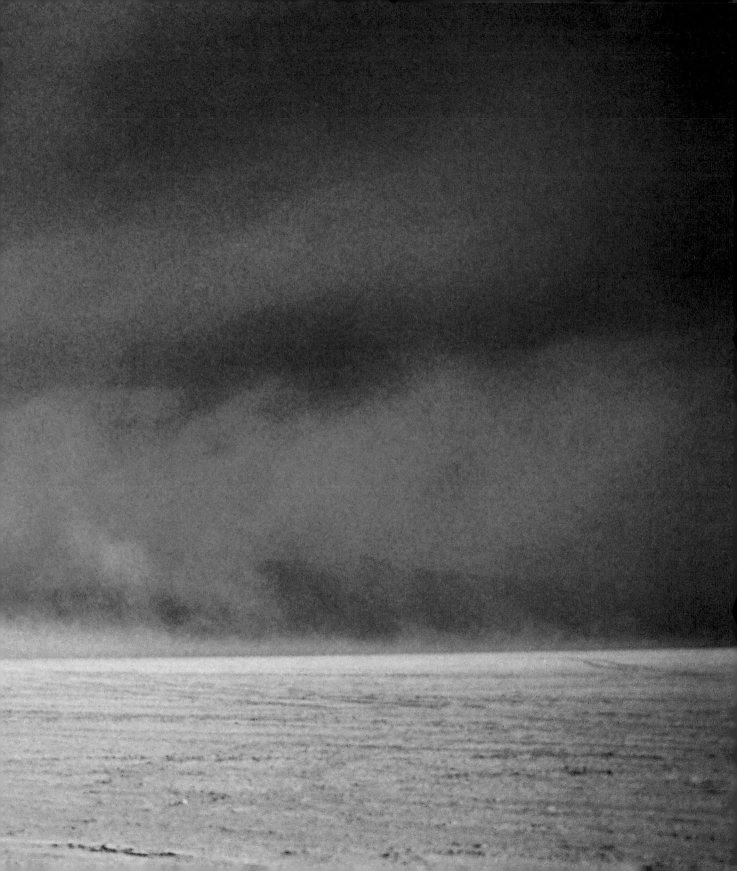

Literally any camera type can be used for landscape photography, from the simplest point-and-shoot to sophisticated models designed for professional use. Ideally, a camera that allows the photographer a good degree of user control is best, with a flexible exposure system and the option of interchangeable lenses especially desirable.

Whatever camera you own or decide to buy, remember that it is just an instrument to translate your vision to film and 'seeing' pictures is very important.

▼ Waterfall and Boat | Trondheimfjord | Norway | Tony Rath | Being there at the right time and right place is obviously the most important aspect of landscape photography but you will also need some basic camera skills. Helping you acquire these skills is what this book is all about.

cameras introduction

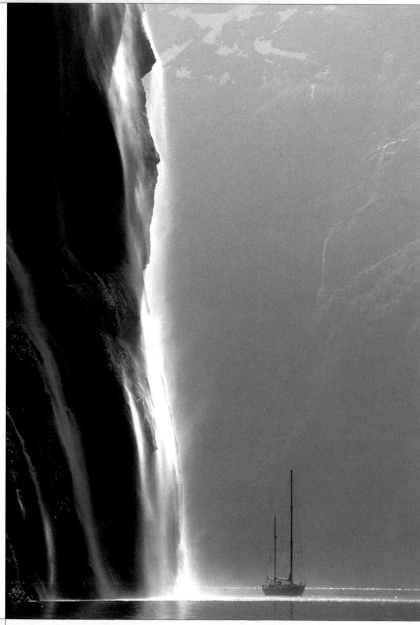

35mm single-lens reflex (SLR)

The most popular type is the 35mm camera producing an image measuring 24x36mm approximately. While these produce a relatively small slide or negative such is the quality of today's films that the originals can be enlarged to 20x16in with minimal grain and loss of sharpness.

The 35mm single-lens reflex (SLR) is a tremendously versatile camera with many exposure modes, automated functions to make picture-taking easy and, most importantly, the option of interchangeable lenses.

Most camera systems offer a huge range of lenses and every conceivable creative vision is catered for, from extreme wide-angles to long telephotos.

In short, with their controllability, portability and versatility a 35mm SLR with a few important accessories is eminently suited to scenic photography, especially when the situation is changing rapidly.

Medium- and large-format cameras

Medium-format cameras vary greatly in size and in the way they operate. Many models are relatively slow to use and are best fixed to a tripod to avoid camera shake. But this also means the whole process of taking a picture is much more considered which can lead to better results.

Larger originals still are possible with a large-format camera. Such beasts use sheets of film (5x4in and 10x8in are common) loaded into special lightproof holders. Inevitably, they are slow to use and running costs are high so photography with a large-format camera is a very deliberate process, and it is this leisurely aspect that many people enjoy.

▶ Milford Sound | South Island | New Zealand | Matheson Beaumont | The advantage of a camera with a zoom lens is that it will let you compose very precisely so you can easily exclude any distracting details.

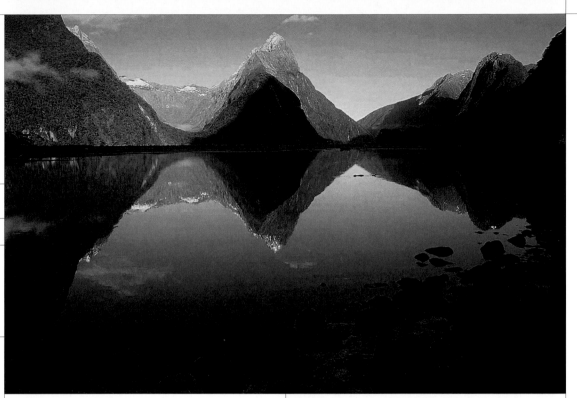

Cameras

Mamiya 7II – This 6x7cm format machine is perfectly suited to location photography. It's light for its format size, handles well and is solidly built.

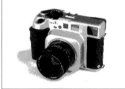

Nikon FM3A – 35mm SLR cameras are quick handling and compact, making them superb for carrying around. Most systems have a huge system of supporting lenses so you can be creative with your lens choice.

Pentax 645NII – Lots of high-tech features. This model is quick to use and gives 6x4.5cm format images.

Roll-film cameras

If you want to improve on the quality of 35mm film the thing to do is use a camera with a larger image area. It is true that so-called medium-format (or roll-film) cameras are bulkier than 35mm cameras but they give higher picture quality. But it is not just the camera's size that is bigger. The lenses are bigger, the filters you need will have to be wider and accessories, such as the tripod, need to be more robust to hold the heavier machine steady.

This camera type uses 120 or 220 roll-film (the latter is twice the length of the former) and there are many film types to choose from. From these film sizes there are several different formats possible. The 6x6cm square format is popular but many landscape photographers prefer the rectangular shape of the 6x4.5cm, 6x7cm or 6x9cm formats. It is argued that rectangular formats suit scenic shooting more, and that square images are frequently cropped down anyway so why not shoot in the right format in the first instance.

Panorama cameras

No discussion of cameras suitable for landscape photography would be complete without mention of the panorama camera. These are designed to produce long, thin, 'letterbox-shaped' images and are ideal for capturing expansive scenic vistas.

The simplest panorama cameras are those based on the Advanced Photo System (APS) because panoramic prints is one of the three options. However, there are plenty of dedicated panoramic cameras available in 35mm and roll-film formats. The actual image size varies according to the model but models that give a 6x17cm image are popular. However, shooting this format allows only pictures on a roll of 120 roll-film so it is expensive.

Fact file 1: Ash Tree and Limestone Pavement	**Technique**

Photographer: Geoff Doré

Location: Yorkshire Dales, UK

Conditions: Early sunny evening in late spring

Camera: Nikon FE2, lens: 28mm wide-angle, film: Kodachrome 25, exposure: 1/2sec at f/16 with the camera on a tripod, filter: polariser

Technique

I spotted this isolated ash tree while I was driving past on a road about 150 metres away. The scene was lit by a late afternoon sun that was dropping rapidly down into a large bank of cloud. I had to park the car, get my gear ready, walk over to the location and explore camera angles very quickly. I took an exposure reading from a brightly lit limestone pavement which I used as my mid-tone. I managed a few frames before the sun disappeared into the clouds and the magical early evening light had gone.

apertures extreme depth-of-field

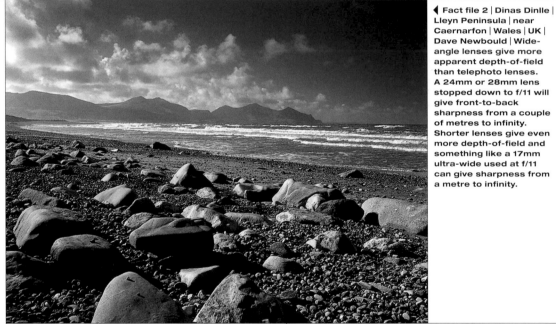

◀ Fact file 2 | Dinas Dinlle | Lleyn Peninsula | near Caernarfon | Wales | UK | Dave Newbould | Wide-angle lenses give more apparent depth-of-field than telephoto lenses. A 24mm or 28mm lens stopped down to f/11 will give front-to-back sharpness from a couple of metres to infinity. Shorter lenses give even more depth-of-field and something like a 17mm ultra-wide used at f/11 can give sharpness from a metre to infinity.

Colour

The sun was at 90 degrees to the scene so I knew a polarising filter would have maximum effect. I fitted one and rotated it until I found the effect I wanted: the richest possible blue sky, the white clouds showing prominently and no glare from the ash tree's leaves.

Composition

The low oblique sunlight shows beautifully the unevenness and texture of the limestone pavement while its gullies (called grykes) in shadow give natural lead-in lines to the tree. The use of a wide-angle lens has increased this compositional effect and strong lines run right up to the camera.

It was windy on this day so the clouds were scudding across the sky quite quickly. With this shot, I waited until one cloud moved to the top left of the scene to give a 'balanced' composition.

Camera tip

There are two types of polarising filter: linear and circular. This has nothing to do with the filter's physical shape, but it is important you have the right type of polarising filter for your camera. The wrong one will result in inaccurate exposures. As a guide, all autofocus SLRs or any camera with a spot or selective meter will need a circular polariser. Check the camera's instruction manual for more advice.

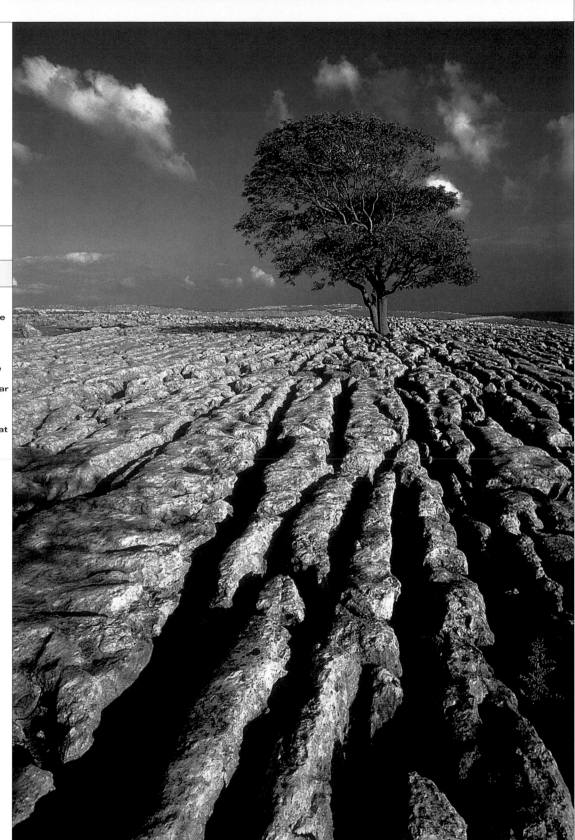

Camera tip

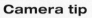

Keep your eyes open. It is really easy to miss potentially great landscape pictures, especially if you regularly drive, walk or cycle the route. Watching the light and how it plays on the scene, studying the variations of different seasons and seeing familiar views in different weather conditions, can all lead to excellent landscape photographs of scenes that you take for granted.

Fact file 1: Grasses in the Sky

Photographer: Chip Forelli

Location: North Island, New Zealand

Conditions: Mid-afternoon, sunny, high cirrus clouds against blue sky

Camera: Hasselblad 500C, lens: 80mm standard with 10mm extension tube, film: Kodak Plus-X, exposure: 1/8sec determined with Polaroid film, filter: yellow to darken blue sky

Technique

These marsh grasses were so beautiful, blowing around in the wind. I wanted to capture the feeling of their movement in a still photograph. By their very nature, landscape photographs are often static and using the camera's range of slow shutter speeds for deliberate blur is an effective technique for injecting energy and movement into a scene.

Even though I was trying to purposely blur the grasses, a tripod was essential because I wanted the grasses blurred, not the sky in the background.

Obviously, the longer the shutter speed the greater the amount of blur, so I knew that my choice of shutter speed was crucial to the success of this picture. I used Polaroid instant film to check out the effect and this is how I worked out that the 1/8sec speed was best. A yellow filter was used to darken the sky and make the stalks stand out boldly against that lovely background.

Composition

Accurate composition can be unpredictable because you are reliant on the prevailing conditions and the subject. Here, it was the wind that was moving the grasses around so I just watched for a while before setting up the camera on the tripod.

A low camera viewpoint was important so that the grasses were against the sky rather than against a messy background.

I then chose just a few stalks that gave a balanced composition in the frame and I watched through the camera viewfinder for a while to determine the extent of their movement.

Patience was needed because the wind was very blustery and I wanted strong diagonal lines to give the composition energy.

Camera tip

If you want to try this sort of shot, shoot at a range of shutter speeds because the effect can vary greatly. Obviously, the speed you start from depends on how much blur you want and the speed of the moving subject. For example, the shutter speed to blur a fast flowing waterfall will be much quicker than the speed needed for a small stream. To allow a slow enough shutter speed to get blur you may have to use neutral density filters. These have no effect on the scene's colour reproduction but still absorb light to cut down the amount of light reaching the film. For example, a 4x neutral density or ND filter absorbs two stops of light.

▼ Fact file 3 | Iguazú Falls | Brazil-Argentina border | Tom Till | Pictures of flowing water can pick up a blue colour cast. To avoid this try using an 81B or similar warm-up filter which will stop the image going too blue.

using shutter speeds going for movement

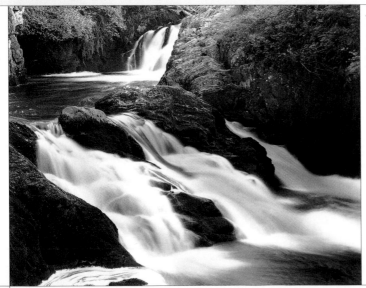

◀ Fact file 2 | Beezley Falls | Ingleton | North Yorkshire | UK | Phil Handforth | A standard cable or electronic remote release to make the exposure is essential for this sort of shot. It means you are not touching the camera which can cause camera shake and, more importantly, it lets you precisely time when to take the picture. Using the camera's self-timer to make the exposure does not give the same degree of control. Of course, in scenes where timing the exposure is less important, i.e. shooting a waterfall, a self-timer is perfectly fine.

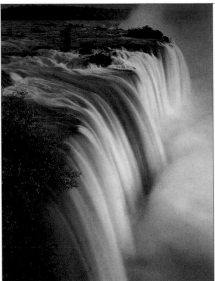

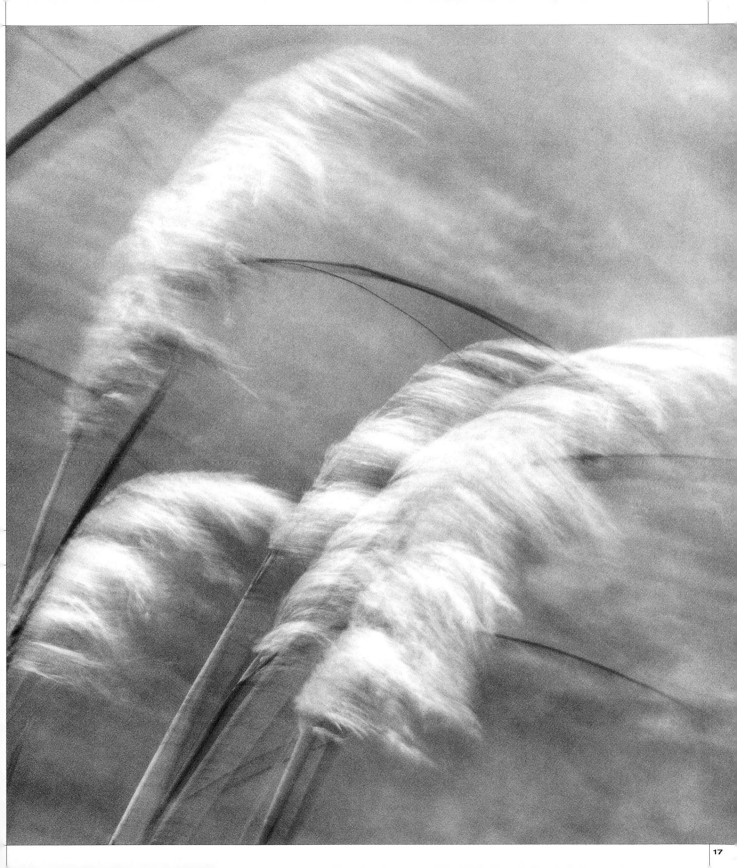

Fact file 1: Bristly Ridge

Photographer: Dave Newbould

Location: Bristly Ridge, Glyder Fach, Snowdonia, Wales, UK

Conditions: Calm early morning, soon after sunrise, about 8am

Camera: Minolta Dynax 700si, lens: 24–70mm at 24mm setting, film: Fuji Velvia, exposure: 1/2sec at f/22 with the camera on a tripod, no filters

how to meter awkward light

Camera tip

Pure landscapes can lack scale and including something instantly recognisable helps provide it. People themselves are excellent for adding that extra dimension of scale, but make sure that they suit the composition. The wrong look or the wrong clothes can jar rather than enhance the picture so avoid, for instance, someone in a red jacket or groups of people when a single person or a couple would be better. Of course, this can mean patience and lots of it, but you will find the extra effort thoroughly worthwhile.

Colour

Early morning light can be very delicate and the subtle hues of this strongly backlit scene have been superbly rendered. This picture is also a fine example of what is known as aerial perspective. This is a visual effect where distant subjects appear less saturated and lighter in tone due to the effects of distance and haze.

Technique

The area is a well-known climbing/scrambling route and my idea was to climb Glyder Fach at night and be on the summit ready to shoot at sunrise. I always check the weather forecast before going off anywhere and knew the sunrise could be good.

I took a gullible mountaineer friend as a model and he was very patient, trying out a variety of poses as I shot away.

The bright sun was a potential exposure headache and, of course, I wanted to retain the delicacy of the mist in the valley. I angled the camera down slightly to make sure the sun was excluded from the viewfinder and took a reading, then bracketed exposures around this.

Composition

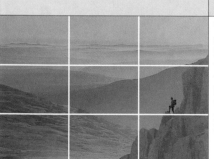

This picture is an excellent example of the effectiveness of the rule of thirds. The distant horizon runs across the line of the top third while the near foreground dominates the bottom left third. The result is a beautifully balanced picture, but what really makes the image a success is the lone figure in the foreground. Cover him with your finger and you suddenly find that the picture has lost scale and depth.

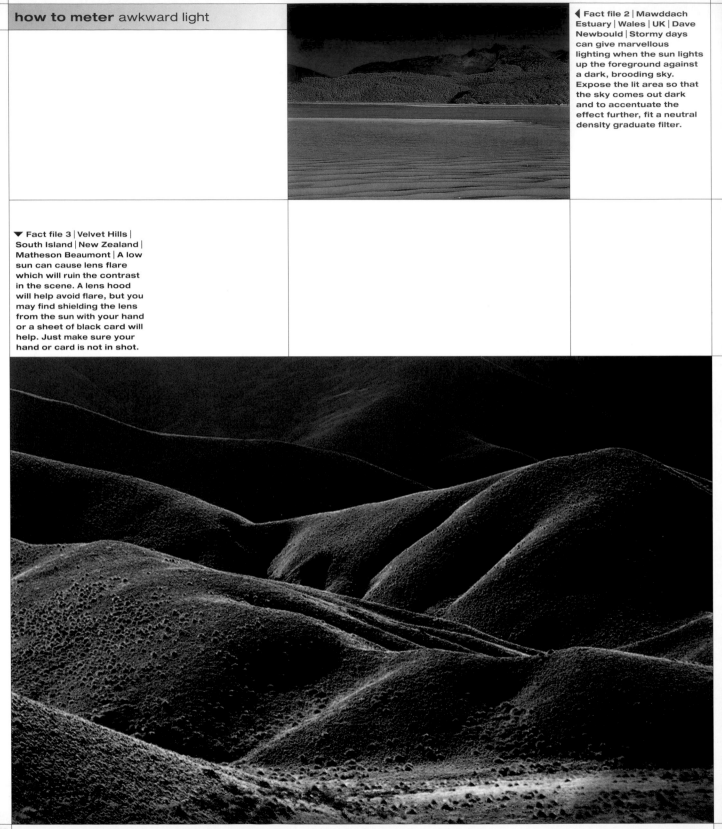

▼ **Fact file 3 | Velvet Hills | South Island | New Zealand | Matheson Beaumont |** A low sun can cause lens flare which will ruin the contrast in the scene. A lens hood will help avoid flare, but you may find shielding the lens from the sun with your hand or a sheet of black card will help. Just make sure your hand or card is not in shot.

▶ Fact file 4 | Sierra Nevada | near Conway Pass | USA | G. Arnell Williams | Flare is almost inevitable when shooting directly into the sun, but the results can be dramatic. Exposure bracketing is essential in such contrasty conditions. Start by taking a meter from a bright area of the scene, excluding the sun, and bracket exposures from there. A word of warning: looking at the sun through a camera lens can damage your eyesight.

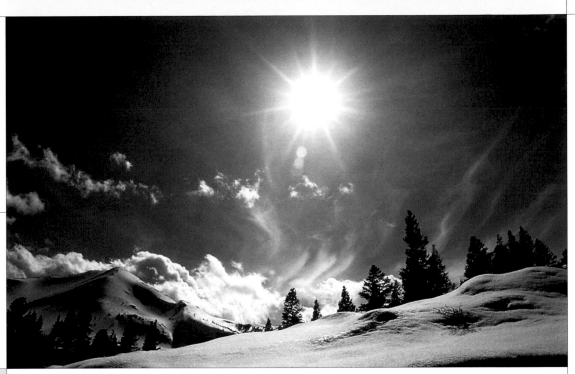

Camera tip

Exposure bracketing is a useful technique to know about but it should be used sparingly. It guarantees a good picture in extreme lighting conditions when you are not absolutely certain that the shot will come out the way you want. Bracketing means taking extra exposures at above and below the camera's meter reading. Experienced shooters often only bracket one direction, i.e, above or below the meter reading. By how much to bracket depends on the film and the actual situation. As a guide, with slide film bracket in half-stop steps while with colour print or black-and-white film go for whole stops.

Some of the latest cameras even have an automatic bracketing facility which speeds the process up.

Fact file 1: Exmoor Sunrise

Photographer: Will Cheung

Location: Exmoor, North Devon, UK

Conditions: Cold but dry early autumn morning. The sun had already risen, but was hidden by a bank of low-level cloud until it suddenly broke through causing the moisture off the fields to quickly evaporate

Camera: Canon EOS 3, lens: 70–200mm, film: Kodak Elite Chrome 100 Extra Colour, camera hand-held, exposure details not noted, no filters

Camera tip

Many SLR cameras are autofocus and very dependable they are too. But care needs to be taken when there are no obvious strong lines for the focusing system to lock on to. The same also applies if an important part of the scene is off-centre. The sun can cause flare and a sheet of card held to stop any direct light striking the front of the lens will help avoid this.

Colour

Mother nature can often do an incredible job of producing breathtaking colours and the photographer need do no more than be there to capture the scene on film.

Just look at this picture: the low early morning sunlight was wonderfully warm and did a beautiful job of backlighting the mist. All I did was stand there and take the shot. No tinkering with filters or special creative techniques were necessary.

Composition

I spotted this sheep earlier before the sun weaved its magic and I knew it would look just right – provided that it didn't run away.

The sheep makes this picture. Place your thumb over it and imagine that it was not there. See how the picture loses interest. Yes, the great colouring is still there but successful images need more than pretty colours to stand long-term scrutiny.

I composed the image with the sheep at the intersection of two thirds to create quite a traditional composition.

how to meter shooting into the light

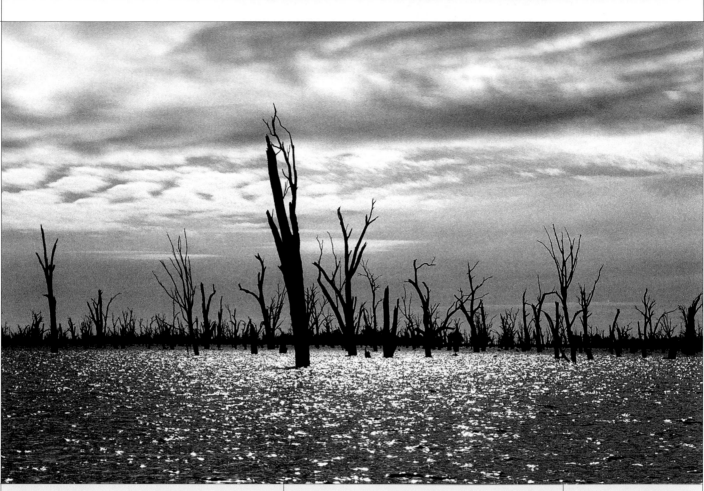

Technique

One thing all landscape photographers need in abundance, but which cannot be bought is patience. Waiting for the right light or for someone to walk out of the picture are obvious examples.

This picture is an example of short-term patience. The sun had risen without any drama or colour and there was significant cloud cover. I was with several photographers and they just packed up and left, but I decided to stay just hoping for something to happen. And it did. It was much better than I could possibly have imagined. The lighting went from dull and bland to amazing in a matter of minutes.

The strong backlighting was a potential exposure nightmare and just shooting away on automatic would have given poor underexposed results. In this instance, the camera was angled down slightly to include some foreground then the exposure lock was used to hold the reading before the picture was recomposed.

▲ **Fact file 2 | Flooded Gums | Murray Valley | Australia | Andy Piggott | Shooting into the light when the contrast is not too extreme is easy enough, especially if you are after a silhouette effect. This was taken with a straight meter reading as a break in the clouds let through a ray of light. The bold shapes of the gum-trees set against the lighter toned sky and specular highlights in the water have come out perfectly.**

Fact file 1: Fishing Boats

Photographer: Will Cheung

Location: Ullapool, Scotland, UK

Conditions: Rainy, dusk, late autumn

Camera: Canon EOS 3 on tripod, lens: 70–200mm f/4, film: Fuji Provia 100, exposure: 30secs at f/8

Composition	Technique
It is easy to overlook the background but this part of the photograph can have a huge impact on the composition's success. Here the distant cool-looking mountains provided an ideal backdrop for the line of fishing boats. I shifted camera viewpoint several times in order to get the boats against the best line of hills.	The low lighting levels meant that a long shutter speed with the camera fixed on to a tripod was essential. With the lens set to f/8 and aperture-priority mode, the camera chose 15 seconds. Because of the speed loss caused by reciprocity failure I gave an extra stop so the exposure became 30 seconds at f/8. A remote release was used to release the shutter and a pocket torch was useful to check camera settings. The biggest problem was that even on a calm evening the boats were moving very slightly. I took several shots and just hoped that I managed one without any movement.

how to meter mastering low light

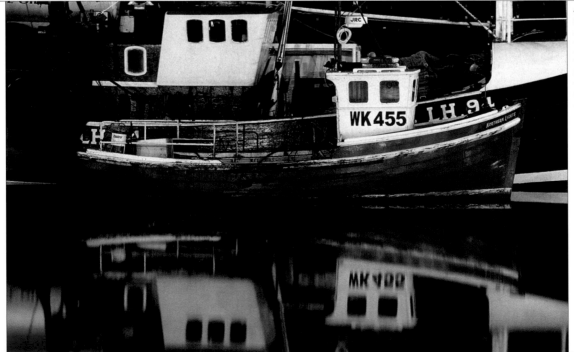

◀ Fact file 2 | Ullapool | Scotland | UK | Will Cheung | A matter of metres from where the main picture was taken was this scene. The still water produced a lovely reflection of the fishing boat and there was no blur even with a long 30-second exposure.

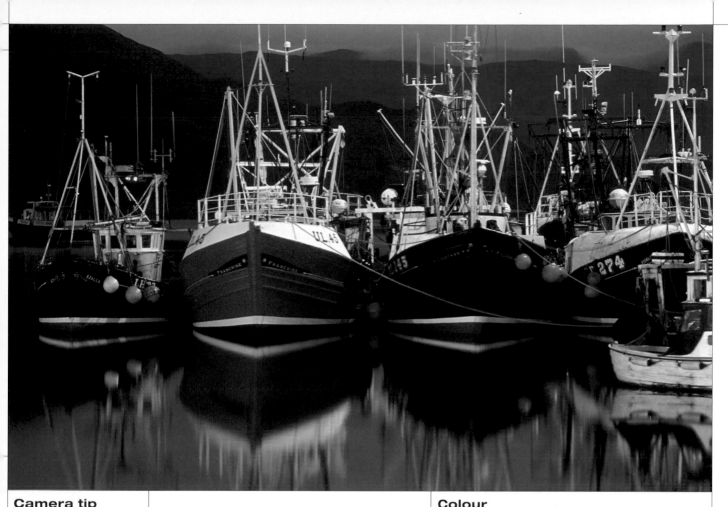

Camera tip

Many photographers prefer to rely on a separate hand light meter rather than the meter built into the camera. Most hand meters are very sensitive and can be used for ambient as well as flash lighting. However, a major advantage of a hand meter is the ability to take incident readings which means measuring light falling on to the subject as opposed to light being reflected. With subjects which are predominately dark or light-toned, an incident reading gives a more reliable reading.

Colour

Dusk lingers in Scotland and the rain-laden clouds imparted the distant mountains with a strong blue hue and it was this with the fishing boats in the foreground that I wanted. Lighting on the boats was from harbour lights and these were shot unfiltered on daylight slide film which resulted in a warm colour cast. The contrast with the flood-lit boats against the cool background has produced a lovely contrast.

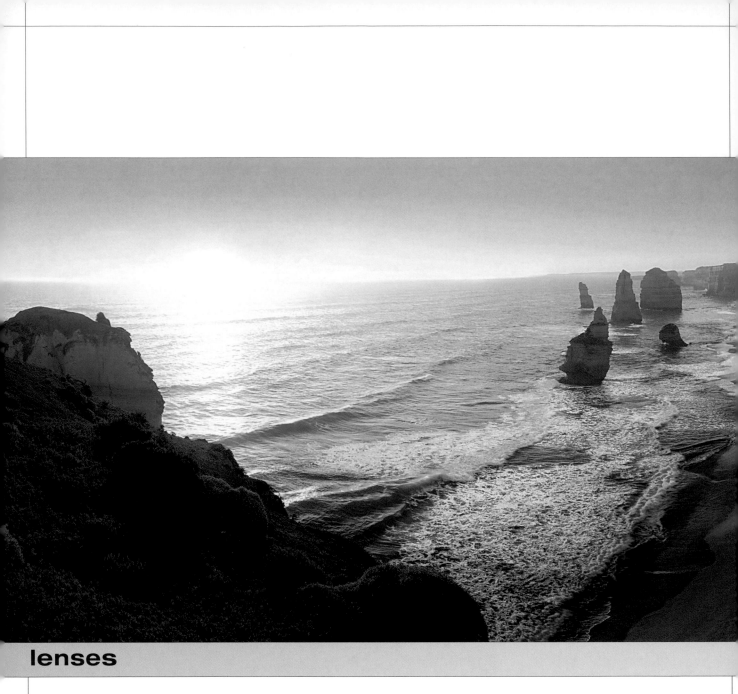

lenses

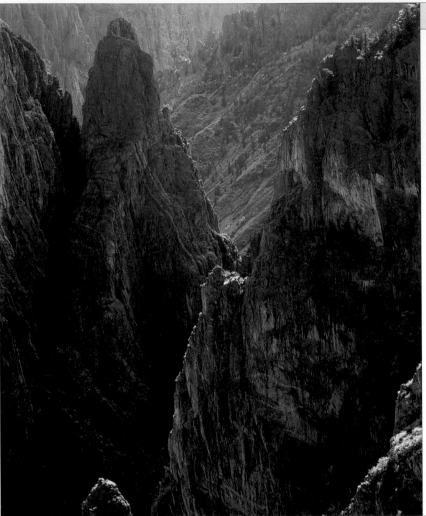

Telephoto lenses

Lenses longer than the standard focal length are known as telephotos and give a more magnified image on film. In the 35mm format, lenses from 85mm are telephotos and the longer the focal length the greater the magnification.

For landscape work lenses within the 85mm to 300mm range are the most useful; long enough to pull in detail and isolate subjects without being physically too big to carry around and use. Zoom lenses with a range of 75–300mm are ideal for landscape work if you want to travel light and have one lens covering a wide range of photo opportunities.

Telephotos are superb for picking out interesting details or patterns formed by the landscape and they also give a perspective compression effect where subjects can appear on top of each other.

A great deal of scenic photography is done with the camera on a tripod and this is especially important with a long lens. Camera shake is a real risk so a stable tripod is important. Using this together with a cable release to fire the shutter is advised.

We all have different ways of interpreting the scenes in front of us so choose lenses that suit your creative vision best.
◀ **Gunnison Black Canyon | Colorado | USA | Christophe Cassegrain |**

▼ **Ben Boyd National Park | South Coast | New South Wales | Australia | Leo Meier**

lenses introduction

Lenses are your 'eyes' and the modern photographer is blessed with a huge variety of options to suit every possible vision, from extreme wide-angles to mammoth telephotos.

Most lenses sold nowadays are zooms, which means that they are tremendously versatile optics usable at any focal length within their range. Furthermore, because a zoom effectively replaces several lenses in your kit, it offers significant weight and cost savings.

Zooms dominate in the 35mm format but lenses with a single, fixed focal length – called primes – remain popular for medium and large-format photographers.

For landscape photography in the 35mm format, a focal length range from 24mm to 200mm should cover most eventualities.

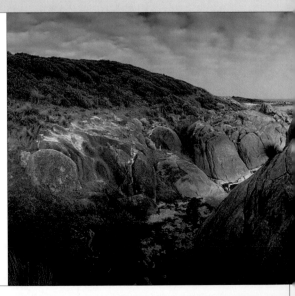

Wide-angle lenses

In the 35mm format, a wide-angle lens means those with a focal length range of 35mm and shorter. There are lenses shorter than 13mm but these are fisheyes which give a round image on the rectangular film format. These are for specialist rather than general use.

Lenses inhabiting the 13mm to 20mm domain are known as ultra wide-angles. Straight lines still come out straight and the angle-of-views are very wide indeed. The only exception to this general rule is the 16mm focal length that is usually a full-frame fisheye so straight lines come out curved.

For immensely powerful foregrounds these are the lenses of choice plus, used at mid to small aperture, everything from a few feet to infinity will be in sharp focus.

For comparatively more gentle wide-angle effects, the 24mm, 28mm and 35mm focal lengths are the ones to use. They can give dominating foregrounds, but the perspective is less dramatic and means they can be easier to use effectively.

If there is one technique that must not be forgotten when using wide-angles, it is to use your feet. It is easy to shoot away without getting closer or changing viewpoint yet both simple techniques can make a world of difference to your shots.

Macro lenses

Shooting close-up landscape detail is worth doing. Most lenses focus plenty close enough but if you want proper macro details you will need an optic that can focus very close indeed.

Macro lenses are specially designed to focus close without compromising high image quality. Mostly, with a few exceptions, macro lenses are within the 50mm to 105mm focal length and give between half (1:2) and life-size (1:1) magnification. Life-size means that a subject measuring 36x24mm will fill the 35mm film frame, which measures precisely that.

▼ Typical examples of (from left to right) a wide-angle zoom, a superzoom covering 28–200mm and a telephoto zoom.

Camera tip

Keep your lenses clean. Dirty lenses can cause lens flare and a loss of picture sharpness, so keep a cleaning cloth and a blower brush in the gadget bag. Microfibre cloths are best and can be cleaned by putting them in the washing machine when they are dirty. Remember also to clean the rear element if you can get to it.

Many photographers protect the lens front by fitting an ultraviolet or skylight filter. Such filters are almost clear so there is no light loss to worry about, but they will also remove any excessive blueness that can be a problem in mountain or coastal areas.

Lens hoods should be used on lenses as standard practice to minimise the image degrading effects of lens flare. Flare can be due to stray, non-image forming light striking the lens front and a hood avoids this. However, with zoom lenses a conventional lens hood has little use and you need a bellows hood that can be racked in or out to suit the focal length in use.

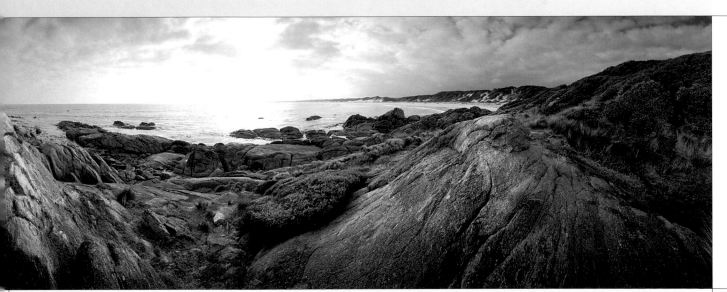

Fact file 1: Whirlpool at the Edge of the Earth

Photographer: Nathan McCreery

Location: Vermilion Cliffs Wilderness Area, Utah, USA

Conditions: The lighting was dull but there was plenty of tone in the moody sky

Camera: 5x4in, lens: 90mm, film: Kodak T-Max 100, filter: green Wratten 61

using wide-angles lead-in lines

Concept

As I topped a ridge in this amazing area I was greeted by a beautiful circular pattern. Analysis quickly revealed that, even though there was great visual excitement, the scene was low in contrast. The challenge was to build enough contrast to make an image that was interesting. I did this by using a green filter and extended development.

Composition

One of the simplest camera techniques that escapes the attention of many camera users is turning the camera on its side for an upright format picture. Do this in combination with a wide-angle lens and there is even more potential for using strong foreground detail.

Technique

Kodak T-Max 100 film was exposed at ISO 50 through a Wratten number 61 green filter. This filter increased the contrast of the red rock sandstone while also increasing contrast and revealing detail in the sky. The film was then given extra development. The print was toned with Kodak Rapid selenium toner mixed 1:1 with water. In the darkroom most of the image was printed using grade 4 to accentuate the contrast in the rock formations while the sky was printed using a grade 2 filter to bring out the detail.

Camera tip

Make the most of black-and-white film by using coloured filters to increase contrast within the scene. A coloured filter lightens tones of its own colour and darkens complementary colours. For example, a green filter lightens green foliage and darkens red tones and blue skies while a red filter lightens reds in a scene and darkens blues and greens.

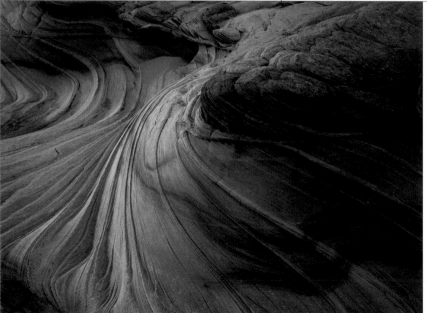

◀ **Fact file 2 | Sensual Stone | Vermilion Cliffs Wilderness Area | Utah | USA | Nathan McCreery | Lead-in lines work effectively with telephoto lenses as well as wide-angles. Perspective is compressed by the longer lens so the effect is less extreme and it is best to shoot at a small lens aperture for as much depth-of-field as possible. This shot was taken on a 5x4in camera with a 210mm lens.**

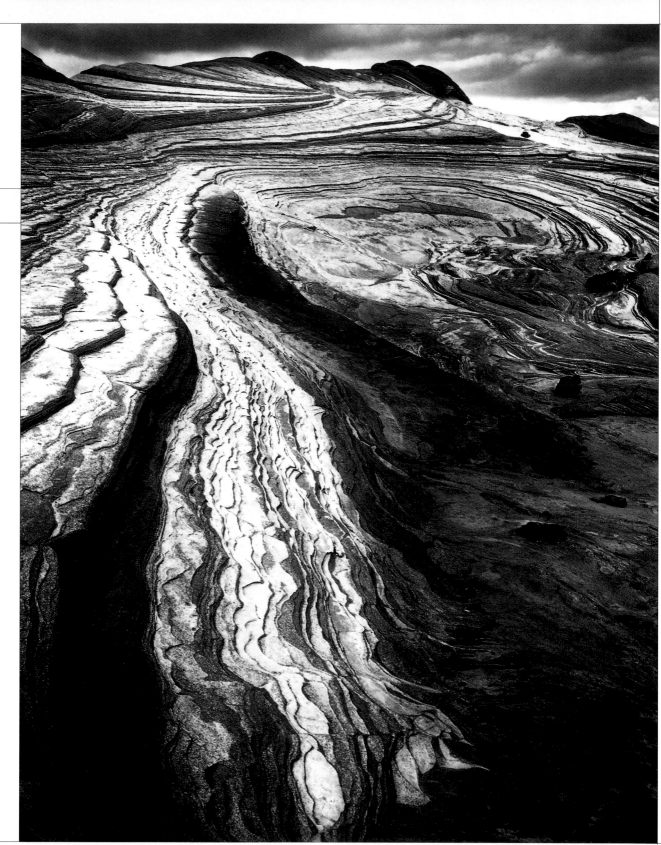

using wide-angles lead-in lines

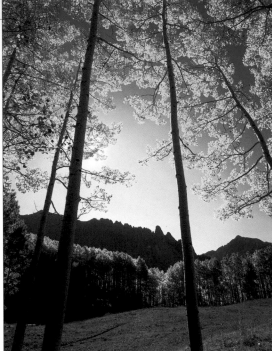

◀ Fact file 4 | Yellow Forest Clearing | near Telluride | Colorado | USA | © Mike Norton | Point any camera up or down to include the top of a skyscraper or, as in this case, some tall trees, and you will experience the phenomenon of converging verticals where the subject appears to be leaning over backwards. It might not look correct but the effect can be dramatic, especially when combined with a wide-angle lens.

▼ Fact file 3 | Crystal Mill | near Marble | Colorado | USA | © Mike Norton | Looking up or down with a wide-angle lens gives an unusual perspective, but keeping the camera back parallel with the subject means any uprights stay that way. To do this often means gaining a higher camera viewpoint or it can be achieved by using camera movements available on large-format cameras.

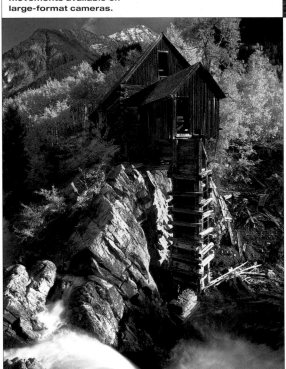

Camera tip

If you have a lens with a depth-of-field scale try focusing hyperfocally for maximum front-to-back sharpness. For example, with a distant subject you will be focused at infinity. Look at the depth-of-field scale and you see that there is 'wasted' sharpness beyond the infinity index. Now if you rotate the lens barrel until the infinity focusing index rests against the aperture value in use, you will see that at the opposite end of the scale you have more sharpness extending closer to the camera.

▼ Fact file 5 | Bodnant Gardens | Wales | UK | Dave Newbould | Trying different camera viewpoints with a wide-angle lens can have radical benefits. Getting down low can be really effective, adding dynamism to any strong lines within the picture. Some tripods can splay their legs for a low viewpoint but you could just try resting the camera on the ground. Viewing can be tricky unless you have a camera with a waist-level viewfinder. Failing that, many SLR cameras have optional right-angle finders in their accessory systems.

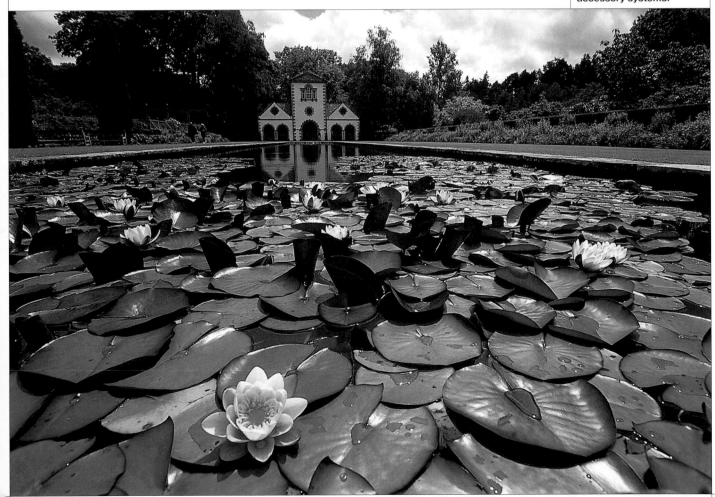

Fact file 1: Poppy Field

Photographer: Will Cheung

Location: A field in Wansford, near Peterborough, UK

Conditions: About 11am on a warm fine day. The sun was intense but there was no wind, which meant no problems with poppies waving about in the wind. A selective meter reading was taken from the central flower itself

Camera: Canon EOS RT, lens: 16mm full-frame fisheye, film: Fujichrome Velvia, camera hand-held, no filters

Colour

I like my colours bold and brash, so I nearly crashed the car in my haste to stop when I spotted this amazing poppy field. There were plenty of flowers at their peak.

The colours were so rich and strong that no filters were needed to further saturate them. Enhancing the scene artificially would risk making the picture look false.

Composition

As a general rule, placing the main interest of the picture centrally in the frame does not work and more often than not it can make for a poor, unbalanced composition which fails to hold the viewer's attention for long. However, I believe that such so-called 'rules' are only there for guidance and on occasion they are worth breaking to give an effective composition.

Technique

For this picture I used a full-frame fisheye lens. This lens type exhibits severe uncorrected distortion which means straight lines come out as strong curves. Such optics need to be used sparingly because the pictorial effect can soon become boring.

These lenses can make everything look small in the final pictures, so they need to be used with care. For this shot I moved in very close, to about 12 inches from the bloom, to make a reasonably-sized flower as the focal point of the composition.

It is worth learning to treat the viewfinder image as an artist would a blank canvas. Vary camera viewpoint by altering your position or try different focal length lenses and continually check out the effect by looking through the eyepiece. I moved in to about 30cm to make the flower as large as possible in the frame.

Using fisheye lenses on landscapes should be conducted with care because curved horizons look odd. Such lenses, however, are much more at home photographing interiors and can give an eye-catching effect. These two slides of Lausanne cathedral in Switzerland illustrate the point. Taken looking straight up at the church ceiling, the 20mm wide-angle gives a powerful result but using the 16mm full-frame fisheye lens has made a pattern out of the scene. Furthermore, the lens's natural distortion has added to the effect.

using lenses fisheye

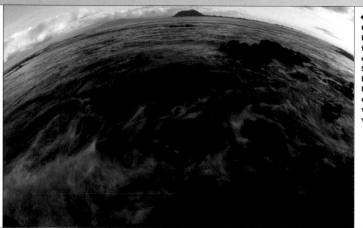

◀ Fact file 2 | Fuerteventura | Canary Islands | Will Cheung | Fisheye lenses give extensive front-to-back sharpness even at wide lens apertures. Such lenses, however, can be prone to flare from bright light sources and because of their extreme angle-of-view, lens hoods are not very effective.

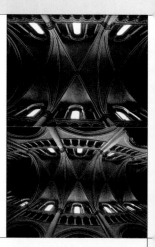

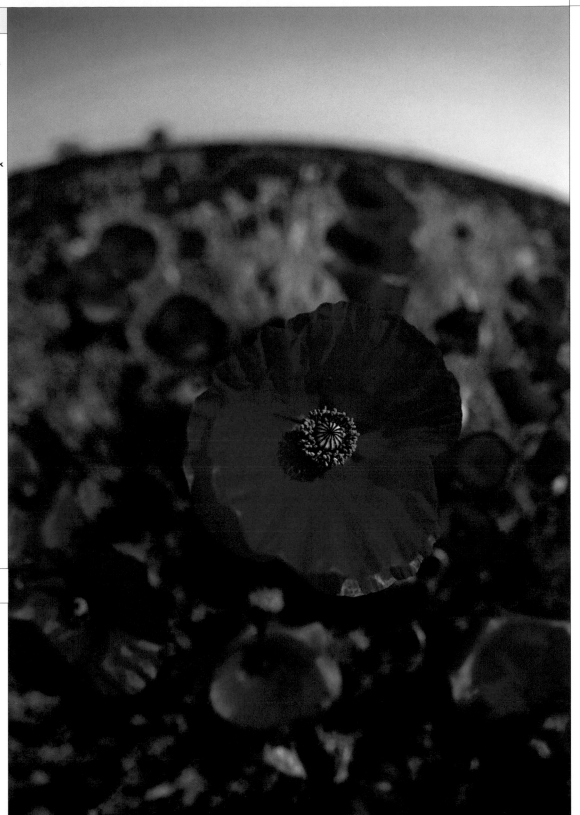

Camera tip

It is very easy when confronted by scenes like this to shoot a few pictures with one lens and feel that you have fully explored the situation. Often that is rarely the case and swapping lenses and camera viewpoints is good advice. You do not have to take any pictures while you explore options so there is no film wastage. Just check out the many possibilities before taking your shots.

Fact file 1: Storm Clouds Clearing

Photographer: Chip Forelli

Location: North-west coast, South Island, New Zealand

Conditions: Late afternoon, summer's day

Camera: Hasselblad, lens: 60mm, film: Kodak Panatomic-X, exposure: 1/60sec at f/16

using wide-angle lenses bold foreground

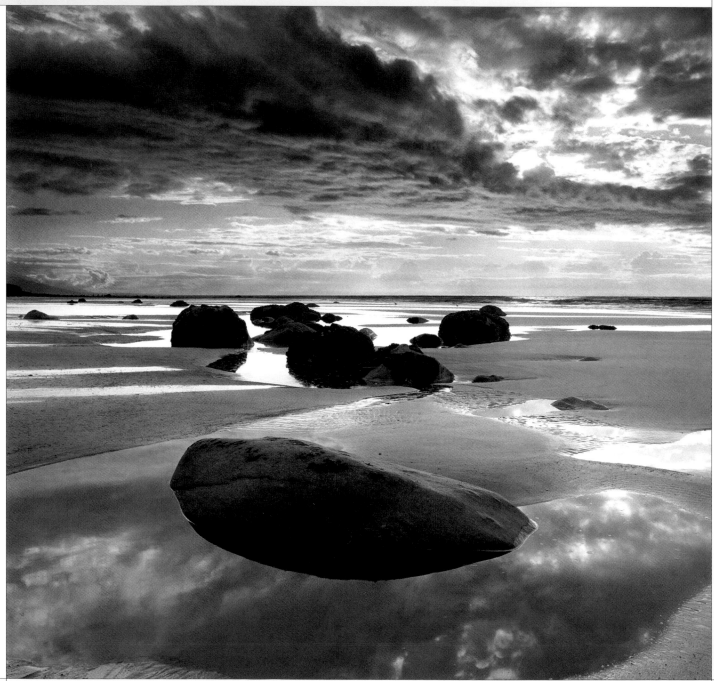

Concept	Composition	Camera tip
It was summer, late afternoon and the sun was going down in the west over the Tasman Sea. I was struck by the spectacular cloud formation underlit, I think, from bright sunlight reflecting off the ocean's surface. I spent plenty of time exploring the foreground. I wanted an attractive arrangement of rocks, but the rock pool has added an extra element to reflect the superb cloud pattern.	I took plenty of time to walk around and find the right composition, but all the time trying not to leave footprints which could spoil the picture. I wandered among the many rock formations, often looking through the camera's viewfinder to check the framing until I was happy with a composition that I felt would work.	**It is worth bearing in mind that moving right in close with an ultra wide-angle lens can distort perspective. This can be used creatively when you want the foreground to dominate the whole frame. Just ensure a small enough lens aperture is used to give as much depth-of-field as possible.**

Technique

No filters were necessary here to make the most of the incredible clouds, but exposure was important. A meter reading from the foreground ensured a negative with lots of detail which printed without hardly any dodging or burning. A small lens aperture recorded everything from the near foreground to infinity sharply.

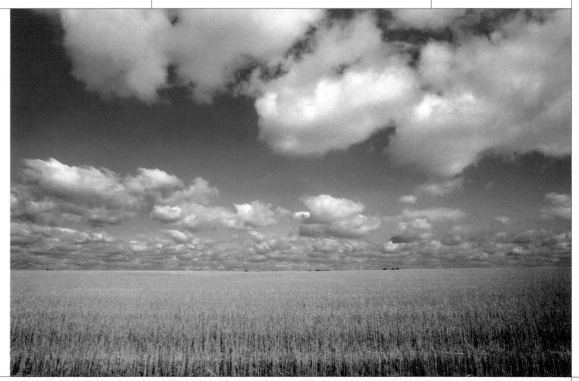

▶ Faot filc 2 | Wheatfield | Western Australia | Kirsty McLaren | Effective foreground detail can be just a broad area of bold colour. Just compose so that the picture has a solid base for the composition to rest on.

Fact file 1: Chicago Buildings	Camera tip

Fact file 1: Chicago Buildings

Photographer: Mark Meyer

Location: This picture of the Chicago skyline was taken from a very popular spot along the shore of Lake Michigan, USA

Conditions: Dusk, soon after sunset

Camera: Nikon F5, lens: 400mm, film: Fuji Provia 100F

Camera tip

Most colour films are sensitised for exposing in daylight and giving lifelike reproduction. There are films which are sensitised for recording artificial light sources such as tungsten lamps and some photographers do switch to this film type for dusk and night photography. However, daylight-balanced films often give better results so the best advice is to continue using your normal film for this type of photography.

telephoto lenses perspective compression

The Drake

Composition

Telephoto lenses compress perspective, making subjects that are in reality some distance apart appear very close together. The longer the lens, the stronger the effect. This 'stacking' effect can be used for all sorts of photography and creates powerful pictorial effects.

In urban photography, compressing perspective can give the impression of crowding but it also has another benefit, namely helping to avoid converging verticals.

Colour

Dusk is always a great time to take pictures because you can capture amazing colour changes as night draws in. The final colour of the scene is not always predictable and it is always worth spending time and taking a sequence of pictures as the lighting changes. The unpredictable colour is partly due to the changing light, but it is also due to the film.

Most colour films are sensitised to be exposed for accurate colours within a shutter speed range of one second to 1/10,000 second. Go beyond this range and there is the risk of what is called 'reciprocity law failure'. This is a loss of film speed and means that with exposure outside of the advised range, extra exposure must be given to ensure correct exposure. As a guide with a typical medium-speed colour film allow one extra stop for exposures between one and ten seconds, and an extra two stops beyond this.

Technique

Due to the extreme telephoto lens, medium speed film and the necessary long exposure, a stable tripod was essential.

Long exposures can also cause a shift in the colour reproduction of the film. Check the film's technical information to find out how to avoid this. However, it is true to say that most photographers rarely go to such lengths and use any colour shift present to enhance the final result.

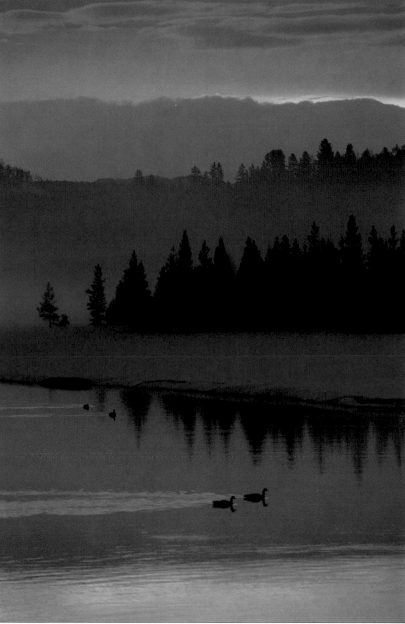

▲ Fact file 2 | Sunrise | Yellowstone National Park | Wyoming | USA | Tony Newlin | Telephoto lenses used in misty conditions give aerial perspective with more distant areas having weaker colour saturation. The resulting pictures with layers of muted colours can be very effective.

Fact file 1: Volterra

Photographer: John Beardsworth

Location: Volterra, Tuscany, Italy

Conditions: Late afternoon in June

Camera: Nikon F90X, lens: 70–210mm, film: Ilford FP4 Plus, developer: Ilford ID-11 diluted 1+1, paper: Agfa Record-Rapid

Concept	Composition
I took this from the roadside, but that caused a major problem in itself. Passing tourist buses and trucks produced a draught and suction effect which made it difficult to keep the camera steady. The late afternoon sun was strong enough to allow a fast shutter speed so hand-holding was no problem, but I still used a tripod. I took both black-and-white and colour pictures of the scene, but I prefer the stronger abstract effect of the mono version.	Cluttered compositions confuse so learn to keep things simple. Here, I placed the solitary tree on the top left third and the white lines in the field take the viewer straight there. When you are peering through the viewfinder it is always worth trying variations of different compositions before taking the shot. In this instance, I did look at the tree at each of the four thirds to see which was the most effective. This was the best largely because of the way the diagonal lines flowed across the image.

telephoto lenses isolate details

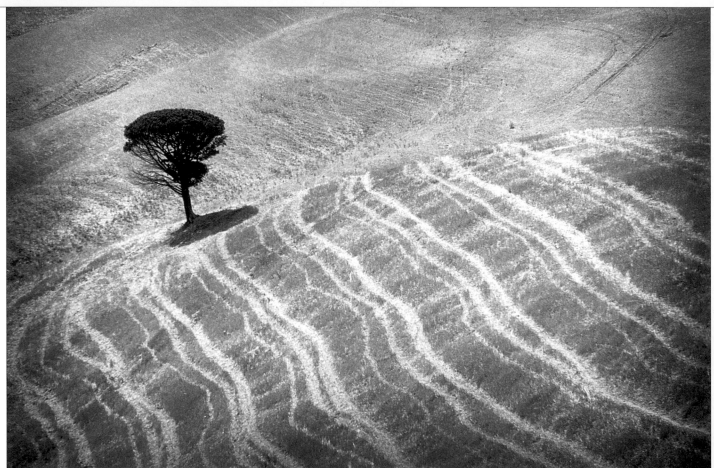

▶ Fact file 2 | McClure Pass | near Aspen | Colorado | USA | Ken Schory | There can be effective photographs hidden away within the overall scene and a telephoto lens lets you pick out these different pictures without moving far. As a visual exercise, next time you are confronted with a stunning vista, fit a telezoom lens and explore the many options. Try a variety of focal lengths, upright and horizontal formats, and place the horizon on different thirds.

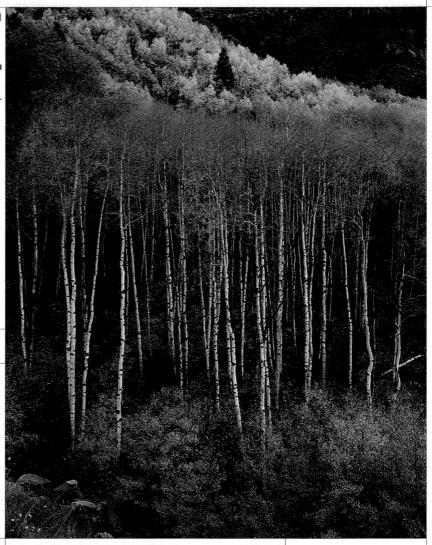

Camera tip

Try varying camera viewpoint before taking the shot. Confronted by a photogenic scene, the instinctive action is to lift the camera to the eye and take the shot. But moving a little to the left or to the right, or climbing a wall for greater height, can have a significant effect on your scenic pictures. If the light gives you time, explore the many possible viewpoints for the best end results.

Technique

Telephoto lenses make distant subjects appear closer but they are also excellent at letting you be much more selective with what is included, and what is not, in the picture. It is worth noting, however, that while trying different viewpoints and moving your feet to get the best angle, it is a little less critical with telephoto lenses.

What is more critical with telephoto lenses is focusing. Assuming an identical camera position, a telephoto lens gives less depth-of-field than a wide-angle lens so there is less room for error.

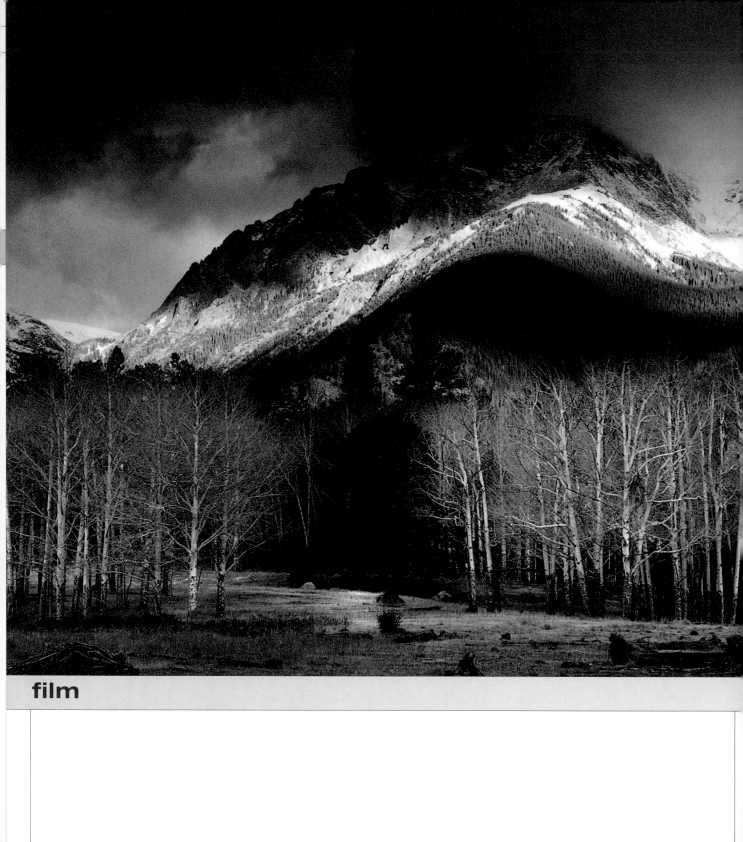

film

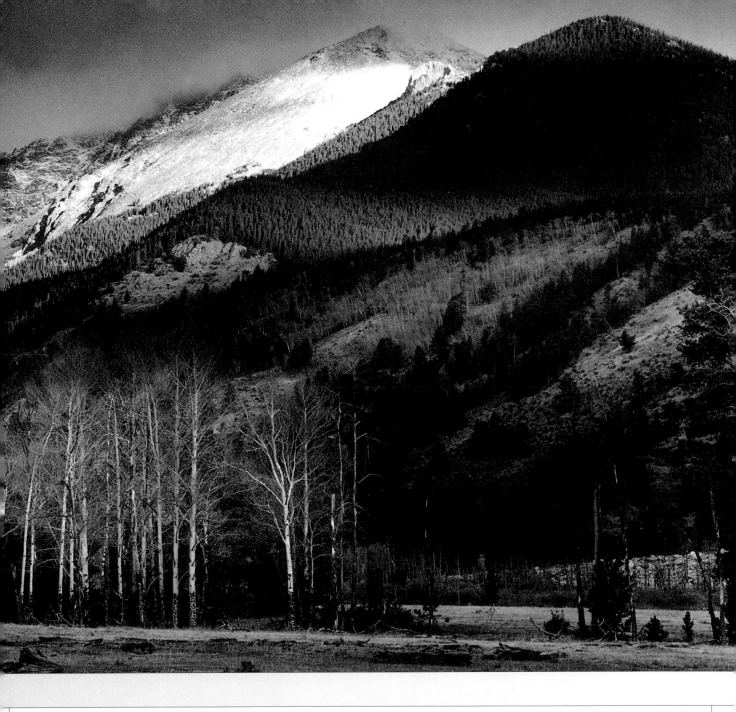

▲ Approaching Storm |
Horseshoe Park | Colorado |
USA | Nathan McCreery |

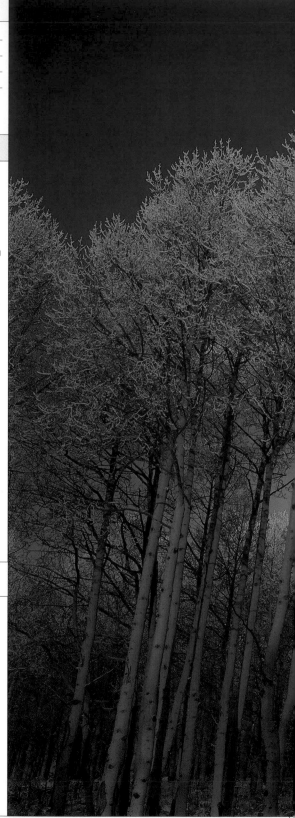

Fact file 1: Icy Aspens

Photographer: Tom Till

Location: Manti-La Sal National Forest, Utah, USA

Conditions: Late afternoon, early winter snow

Camera: 5x4in, lens: 180mm, film: Fuji Velvia, exposure: 1/2sec at f/32

Colour

The aspen trees in this high Utah mountain range have been coated with ice by an early season winter snow. Surrounded by desert and facing westwards, they catch the very last light rays of the day providing the warm colour on the crystalline structures. No filter was needed because the colour was naturally very saturated.

Camera tip

The colour saturation of most slide films can be intensified by very slight underexposure. For example, exposing an ISO 100 film at ISO 125 without altering the processing means that the film is underexposed by one-third of a stop. Be careful though because this technique does not work for every slide film. Also, it is important not to underexpose by too much because shadows can be too dense and the highlights become flat.

Technique

The most important technique to pictures like this is simply being there. It was a freezing cold day high up in the mountains, but knowing that the light could be exceptional I made the effort to stay out relatively late.

An exposure reading was taken from the brightly lit trees because they were the most important part of the scene and this helped to further saturate the already vivid blue sky behind.

film vibrant colours

Composition

Filling the frame is a virtue. One of the most common failings among inexperienced photographers is to leave too much surrounding the focal point. If you have a powerful subject it seems pointless to dilute it with visual distractions and dominating the frame with it makes for a successful image. With SLR cameras showing accurately what will come out on film there is no reason why compositions should suffer in this manner.

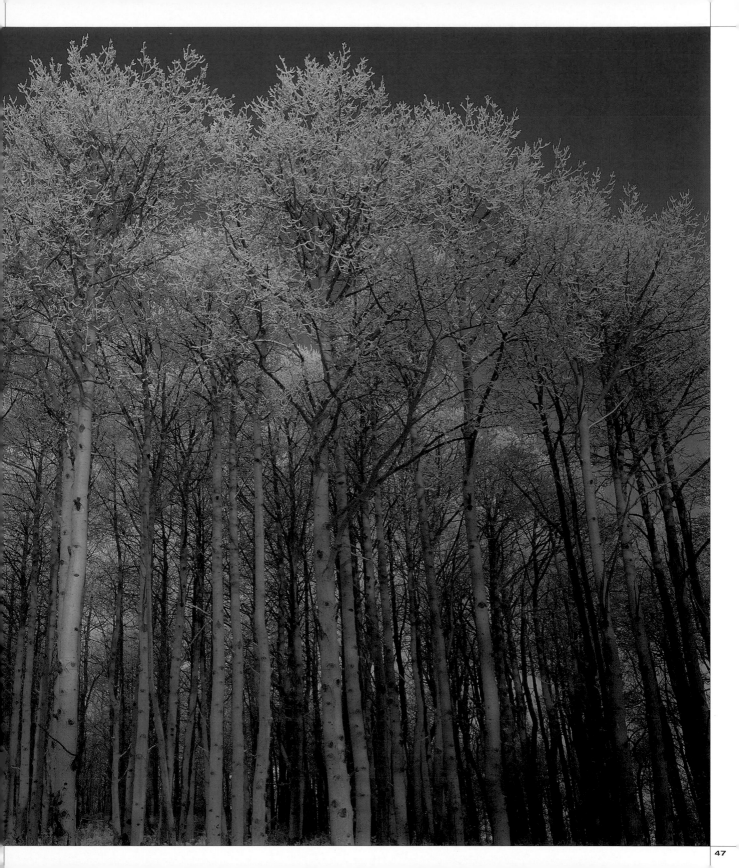

film vibrant colours

▶ Fact file 2 | Manley
Beacon from Zabriskie
Point | Death Valley
National Park | California |
USA | © Mike Norton |
Nature often provides its
own vibrant colours and all
the photographer has to do
is translate them on to film.
Here the photographer
took a spot meter reading
from the pink clouds.

▼ Fact file 3 | Dirt road in
the Eastern Sierra | near
Bishop | California | USA |
© Gary Crabbe | Neutral
density or grey graduate
filters help you control the
contrast range between a
dark foreground and a
bright sky, thus retaining
rich colours in both areas.

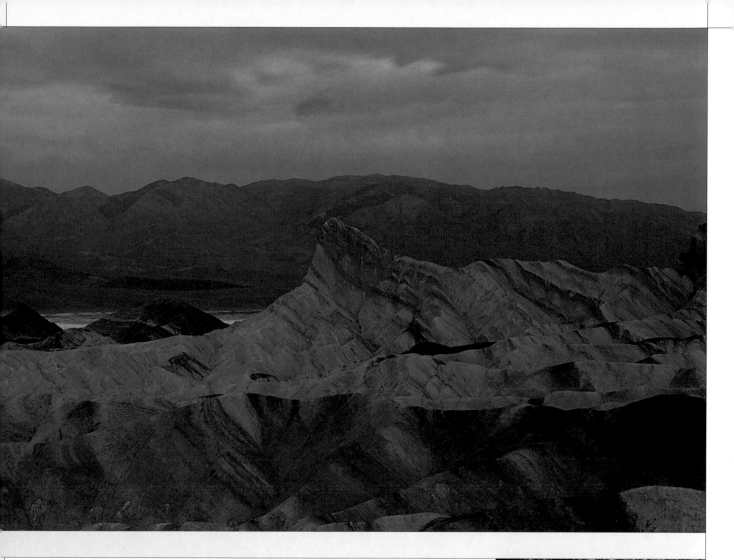

▶ Fact file 4 | Aspen Forest, Autumn | San Juan National Forest | Colorado | USA | Lynn Radeka | A telephoto lens is perfect for isolating patches of vivid colour against more subtle backgrounds.

Fact file 1: Windmill Farm and Cloud

Photographer: Mark Meyer

Location: South Wyoming near the Colorado border, USA

Conditions: The winter sun had set but there was a colourful afterglow

Camera: Nikon F5, lens: 80–200mm f/2.8, film: Fuji Provia 100F, camera on a tripod

colour film long exposures

▼ Fact file 2 | West Waker Building | Chicago | USA | Mark Meyer | A great time for creative building photography is sunset and an hour afterwards. The challenge is balancing the ambient daylight with man-made light. This is one technique to try: take readings from various points – the sky, the building, the road – and shoot when readings fit into a three-stop or less range.

Colour

I was driving home and passed this windmill farm around dusk. I glanced behind and saw this beautifully coloured sky and that fantastic lenticular cloud. I risked a U-turn on the freeway and drove down a dirt road for a good viewpoint. I knew I had little time before the conditions changed so I scrambled for a spot which would allow me to simplify the composition and focus on the graphic nature of what was before me. The sky was naturally graduated and no filters were needed.

Camera tip

Many modern cameras are well equipped to cope with automated long exposure shooting. With shutter speeds timed to 30 seconds and very sensitive light meters it is possible to leave the camera to its own devices in low-light situations. If you prefer the manual option and find that the meter is not sensitive enough to give an exposure reading at the aperture you want to shoot at, get round this by setting a wider lens aperture for a light reading. So, if the meter says one second at f/2.8, you can extrapolate from that a reading of two seconds at f/4, four seconds at f/5.6, eight seconds at f/8 and so on.

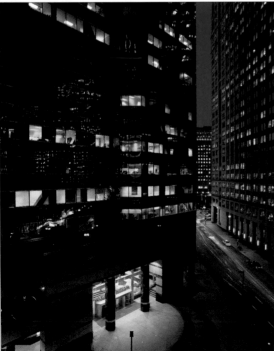

Composition

Clean, simple compositions can be the most effective, especially for silhouette subjects, but what makes this picture is the unusual cloud formation. If you cover that cloud with a finger and imagine the picture without it you will soon appreciate its importance in this image. The line of windmills silhouetted against the richly coloured sky gives an excellent counterpoint to the cloud formation and by placing the horizon very close to the edge of the film frame you avoid too much dark foreground, which can be overly oppressive.

Technique

The sky often goes vivid colours long after the sun has set. To enhance this effect and record the superb colours, I metered off the sky and allowed the foreground to go black. I also wanted to show movement in the windmill blades so I chose an exposure of two seconds. In such low light a tripod with a remote release is essential. How long the colour of a twilight lasts varies, but in the end I had about five minutes of great light before the conditions changed and the cloud had moved on.

Fact file 1: Fjällsarllön Glacier Lake

Photographer: Hans van der Pol

Location: Fjällsarllön glacier lake, central-south Iceland

Conditions: Early evening, an hour before sunset

Camera: Nikon FA, lens: 28–105mm at 28mm setting, film: Fuji Sensia 100, no filters and no tripod

film delicate colours

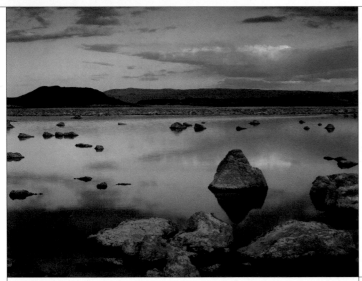

◀ Fact file 2 | After a Rainstorm | Mono Lake | California | USA | Kerik Kouklis | Rain might send some photographers packing off home but perseverance can bring rewards. The times after heavy rainstorms can give marvellous conditions as the clouds clear away. So be prepared to react quickly to capture photogenic plays of light or dramatic phenomenon like rainbows.

Colour

It was the lack of colour that attracted me here. Not every landscape has to be bursting with vibrant colours to be successful. On the contrary, the other extreme, where there are many shades of similar colours can work equally well, giving a 'monochromatic' picture. It is even better, like here, when the colours enhance the overall feeling of the picture. The subtle shades of grey, helped by the soft lighting, fit in really well with the tranquil mood of this Icelandic glacier lake.

Camera tip

If the light is changing quickly you have to grab the shot and a tripod might not be to hand.
At shutter speeds of 1/60 second and above with a standard or wide focal length lens, this is not a problem, but any slower and camera shake is a real hazard. You can avoid ruining your pictures by using what is in the landscape itself. Resting the camera on a rock, fence post or bracing the camera against a tree are all worth trying.

Composition

Horizons running through the middle of the photograph can often result in an unbalanced composition. One exception is reflection pictures where placing the horizon along the centre line gives superb mirror-like pictures, but this is providing there is eye-catching detail in both halves of the picture. A blank sky over a featureless foreground, for example, will not work well. But give a detailed sky over a foreground with the lead-in interest and the result will be a good photograph.

Technique

Just being there sounds obvious but it is where many photographers slip up. An hour before this picture was taken it was pouring with rain, and many photographers might have packed up for the day, but persistence often pays handsome rewards. In this case, when the shower passed the sky started to break up and the light became very photogenic. It was soft which helped bring out the best from this delicate scene. A bright sun on this occasion would have given a very different result and the contrast might have been unmanageable.

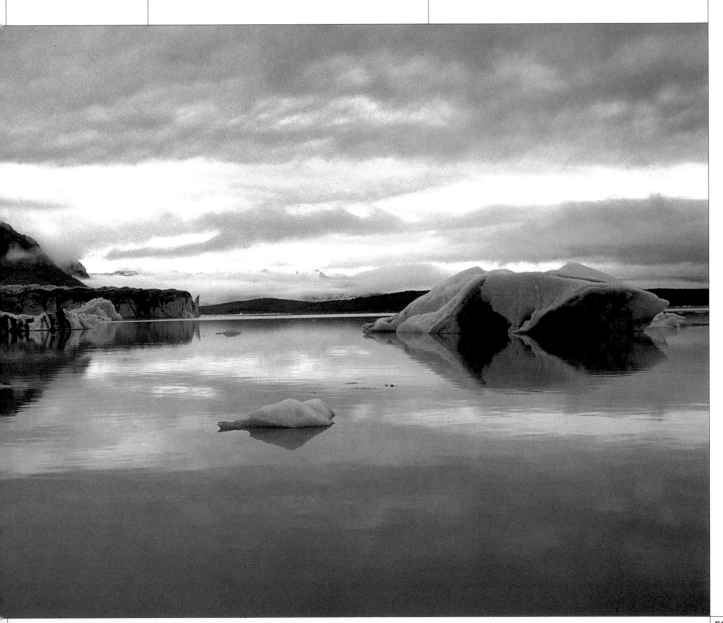

Fact file 1: Cwm Nantcol

Photographer: Dave Newbould

Location: Cwm Nantcol, near Llanbedr, Snowdonia, Wales, UK. In the Rhinog Mountains, the highest of this group, Y Llethr, is seen here

Conditions: Taken in December around midday

Camera: Minolta Dynax 700si on a tripod, lens: 24–85mm set to 28mm, film: Fuji Velvia, filter: polariser and grey graduate, exposure: 1/4sec at f/22

film colour harmony

▲ Fact file 2 | Zion National Park | Utah | USA | Christophe Cassegrain | One of the best times for harmonious colours is autumn. Bright sun can make a scene too contrasty, so wait for it to disappear behind a cloud or just shoot in the shade to keep colours subtle.

Colour

Oblique lighting often reveals colour, tone and texture that is visible when the sun is high in the sky. However, during the winter the sun never gets too high so even at midday the light is very photogenic.

Technique

The foreground and the diagonal line of trees lead nicely to the focal point of this composition, that dominant distant mountain. The composition runs along the top third and the peak sits on the intersection of a pair of thirds.

What completes the composition is a stunning sky with a hue that complements rather than clashes with the rest of the scene.

I nearly always use a tripod as it makes you really look at your composition and think it out more.

Composition

A polariser filter was fitted to cut down the glare of the strongly-lit foliage and thus enhance colour saturation. To help control the contrast range I carefully positioned a grey graduate filter to help retain the moodiness of the sky. I have managed to squeeze a bit more out of this scene than could be seen with the eye by the use of filters.

Camera tip

Shooting into the sun can give problems with lens flare which will degrade the photograph's contrast. A lens hood is strongly advised, so is keeping your lenses clean. Regularly check the rear as well as the front elements to ensure they are spotless and include filters in your cleaning routine too.

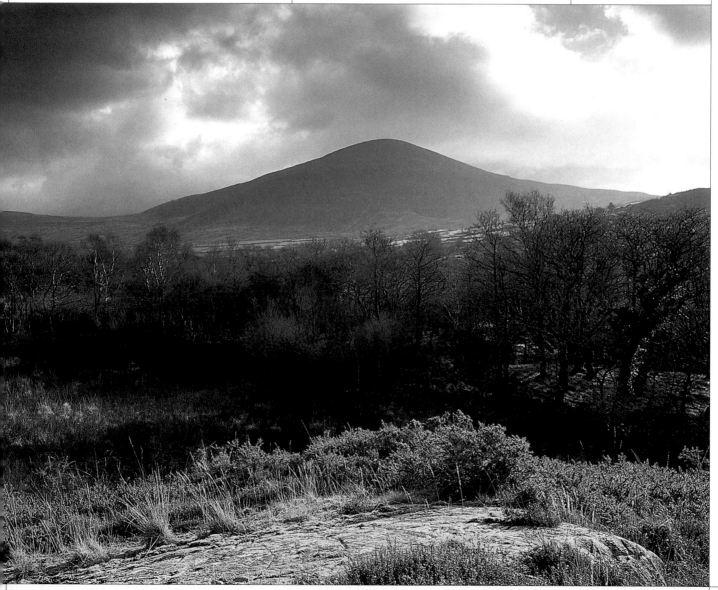

Fact file 1: Glencoe

Photographer: John Beardsworth

Location: Glencoe, Scotland, UK

Conditions: Cold and wet, July

Camera: Bronica SQ-A, lens: 80mm, film: Ilford HP5 Plus rated at ISO 400, developer: Agfa Rodinal, paper: Agfa Record-Rapid, toner: selenium

Concept

I remember being completely overwhelmed by my first sight of Glencoe and I was keen to capture the scale, drama and bleakness of the scene. It was cold and wet on the day despite it being July and the wind was driving the clouds across the sky quickly.

I used my favourite film, Ilford HP5 Plus, because I thought its relatively coarse grain would produce the mood I wanted to capture.

film fast black and white

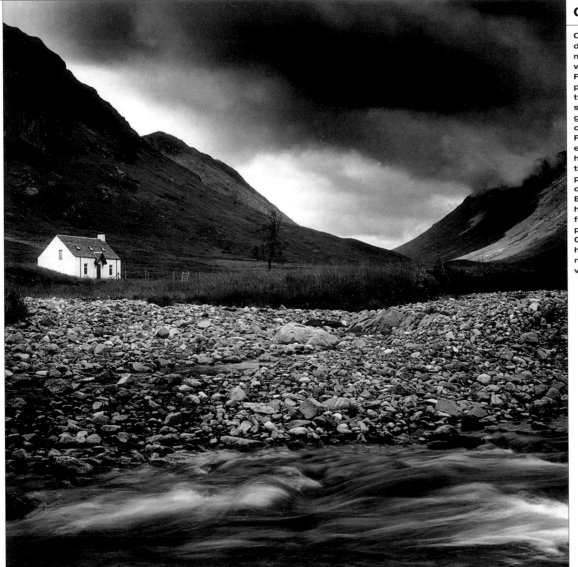

Camera tip

Coarse grain can add a darker, more sombre mood to any image, whatever the subject. Fast ISO 400 films can be push-processed one or two stops to a higher speed to accentuate the grain and the gain in image contrast adds to the effect. Push-processing means exposing the film at a higher ISO and then giving the film a longer processing time in the developer than normal. Either do it yourself in the home darkroom or give the film to a specialist processor.

Choice of developer also has impact on the final result and it is worth trying various types.

Composition

The building, known as Black Rock Cottage, is crucial to the picture's impact as it adds some essential lighter tone in a predominately dark scene. Without it, there would be no sense of place nor any central point of interest. The stream adds foreground while the upward curves of the background hills on both sides assist in keeping the viewer's interest.

Technique

A relatively slow shutter speed was set to allow the stream in the foreground to blur.

I did not use any camera filtration at the taking stage, but in the darkroom I did heavily burn in the sky to darken the mood of the picture.

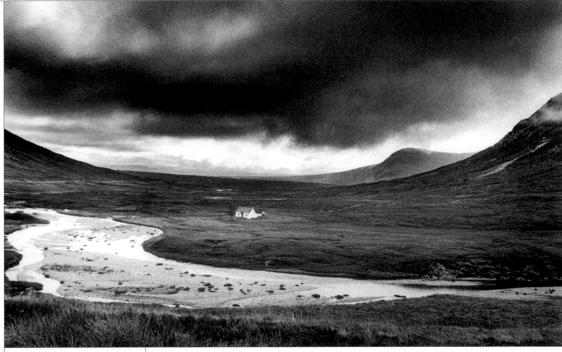

▲ Fact file 2 | Glencoe | Scotland | UK | John Beardsworth | Another moody interpretation of the same location. Black-and-white print manipulation and toning used to need a chemical darkroom, but such effects can now be done using a computer once the negative has been scanned.

Fact file 1: Land of Standing Rocks

Photographer: Lynn Radeka

Location: Canyonlands National Park, Utah, USA

Conditions: Pleasant, bright day with fast-moving clouds

Camera: 5x4in, lens: 210mm, film: Kodak Tri-X, filter: deep yellow

Camera tip

A spirit level slipped on to the camera's accessory shoe will help you to keep the horizon level. Some tripods have spirit levels built in which can also be used.

film textures in mono

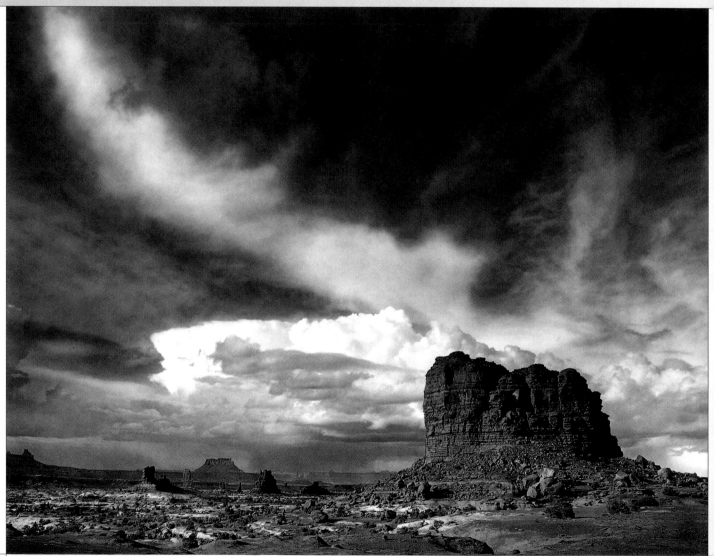

▶ Fact file 2 | Ponderosa
Pine | Angels Landing | Zion
National Park | Utah | USA |
Lynn Radeka | Textures and
patterns are abundant in
the landscape and they
can be very photogenic
especially in black and
white. If you want to get in
very, very close you'll need
a specialist macro lens but
even a telezoom used at its
minimum focus will get you
in respectably close.

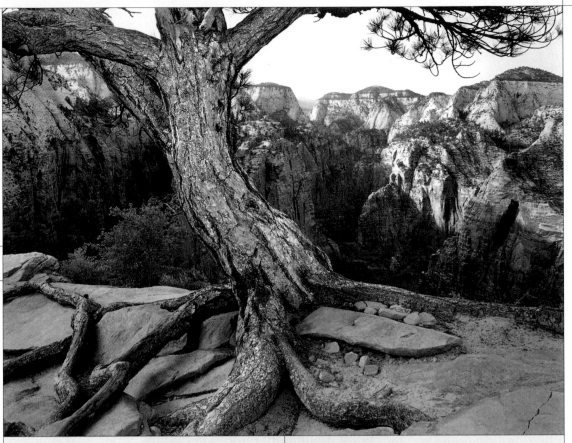

Concept

Along the remote region of Utah's Canyonlands
National Park known as the Maze District, I
noticed an interesting sweeping cloud formation
moving towards the east. Spotting a potential
photograph, I slammed on the brakes of my
vehicle and quickly set up my 5x4in camera.
The cloud had moved into perfect position in
relation to the coarsely textured buttes, and I
was able to make two exposures on Kodak Tri-X
film using a deep yellow filter to darken the sky,
bring out the clouds and cut through some of the
distant haze.

Composition

The sky and cloud formations were amazing and
I wanted to make the most of them, which I did
by placing the horizon along the bottom of the
frame letting the sky dominate the picture.
Composing with the butte on the vertical right
third has given an obvious focal point, without
which this image would not have any impact.

Technique

After shooting the second exposure, I noticed
that a jet vapour trail had encroached into the
image area. My only good negative of this image
is the first exposure without the jet trail. It is a
very difficult negative to print. The main
challenge is achieving a sense of luminosity and
desert light while at the same time not allowing
the image to become excessively high in
contrast.

A series of special contrast masks were used in
printing so that I could achieve luminous detail in
the foreground landscape and allow for smooth
values in the sky. Masking is an exciting and
versatile tool for the photographer. Utilising
contrast masks when printing, the photographer
has amazing control over local or overall
contrast as well as sharpness enhancement,
particularly with black & white prints.

To me this image symbolises the vast and open
wilderness of the American West.

Fact file 1: Dunes and Clouds

Photographer: Alain Briot

Location: Monument Valley, Utah, USA. I was accompanied by a Navajo guide because individual travel is not allowed here

Conditions: It was midsummer and at this time of year clouds build up throughout the day until rainstorms occur in the late afternoon. This was taken early in the day, about 9am, when the clouds were beginning to form

Camera: Hasselblad 500CM, lens: 60mm f/3.5, film: Kodak T-Max 100, no filter, camera on a Gitzo Mountaineer carbon-fibre tripod

Camera tip

Grit and dust inside the camera's film chamber will scratch and ruin the film. It will end up covered in deep, parallel scratches, so keeping the camera interior dust-free is very important. Use a can of compressed air or a blower brush and cloth to dust the interior, taking great care not to touch or harm the shutter blades. Also, rather than do this on location, do any cleaning in the car or indoors.
Care should also be taken while changing films in dusty or sandy conditions. Try to do it inside your jacket or even within the shelter of the camera bag.

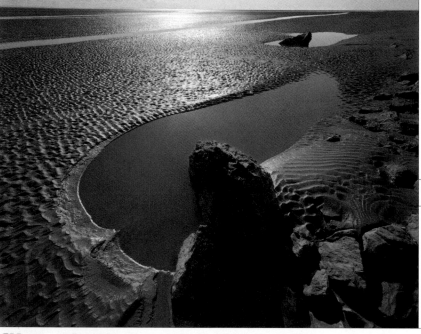

Concept

My original idea was to photograph the Totem Pole, one of the most striking rock formations for which Monument Valley is known, with the sand dunes in the foreground. However, once at the location, I became captivated by the relationship between the dunes and clouds.

I chose to work in black and white because I wanted to eliminate colour, which I thought would be more of a distraction than an asset in this instance. I wanted to create a simple but subtle image and using black and white added an elegance which made the image work better.

Technique

I printed the negative on Oriental New Seagull grade 2, which is a relatively soft paper to create a long tonal range and keep the overall contrast soft and pleasant to the eye.

film choice ultimate quality mono

▲ Fact file 2 | Tidal Flat | Cook Inlet | Alaska | USA | Chip Forelli | Slow and medium speed black-and-white films are capable of incredible image quality but need to be accurately exposed and competently processed to see them at their best.

Composition

I wanted to contrast the flowing lines of the sand with the ethereal quality of the clouds as the sand ripples metaphorically continue up into the sky. The side-lit, detailed ripples in the sand work well as a compositional aid to lead the viewer into the picture.

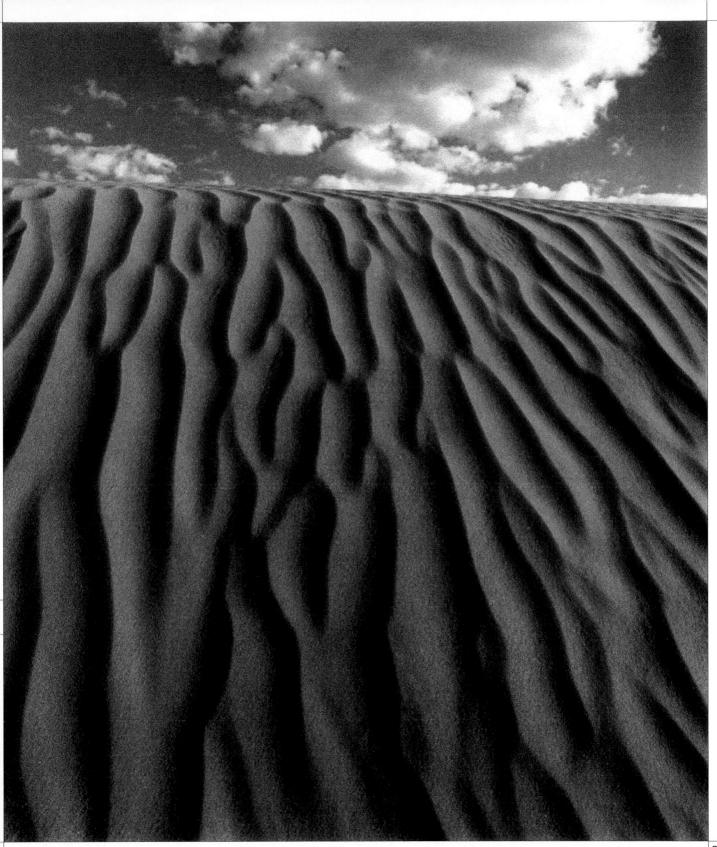

Fact file 1: Kilmartin Stones

Photographer: Hans van der Pol

Location: Kilmartin Stones, near Kilmartin, Scotland, UK

Conditions: It was a very windy afternoon with frequent sunny spells as the clouds were being torn about by the wind

Camera: Nikon FA, lens: 20mm, film: Kodak High-Speed Infrared, filter: red

Camera tip

Invisible infrared radiation focuses at a different focal point compared with visible light. Many lenses have an infrared focus index to make this easy. Just focus as normal, note the subject's distance then adjust the focusing barrel so the noted distance is opposite the infrared mark. However, most zoom lenses do not have an infrared index. So focus as normal and adjust the lens as if the subject were slightly closer to the camera than it really is. With wide-angle lenses setting a lens aperture value for f/8 or smaller will give plenty of depth-of-focus at the film plane to correct for any focusing differences.

special films mono infrared

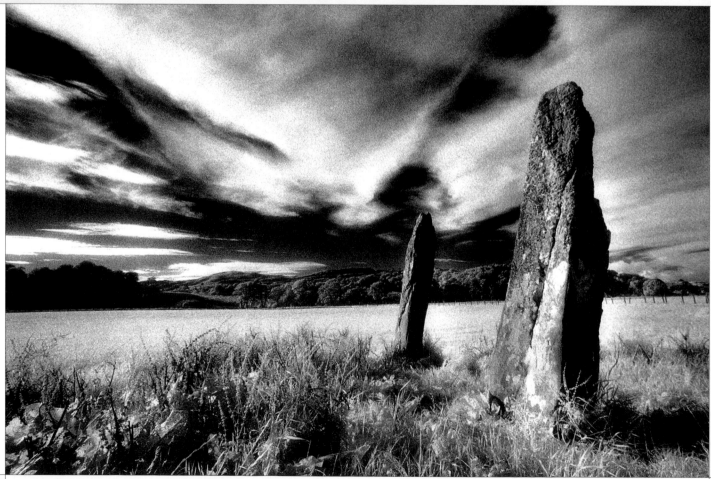

Technique

There are several infrared films available. Kodak's High-Speed Infrared is a black-and-white film with a peak sensitivity of around 900 nanometres. It must be handled in total darkness at all times which includes loading. This film is not suitable for use in cameras that use an infrared sensor in their film transport system because the film's edge will be fogged.

Infrared film can give unpredictable effects until you get used to its behaviour. Some photographers only use it when it is cloudy because they prefer a subtle effect, but it is when it is sunny and there is a lot of infrared radiation around that the most dynamic results can be had.

Exposure bracketing is worth doing with this particular film type because of the unpredictability of the results.

Concept

I was keen to use the scenery, subject and sky in combination for a powerful picture but I also wanted to stimulate the viewer's imagination as the scene did mine when I took the photograph. It is for this reason I loaded up with black-and-white infrared film because I knew its weird, surreal effect would emphasise this.

Composition

Wide-angle lenses are ideal for making the most of bold foreground detail and moving in closer intensifies the dramatic effect further. A small lens aperture gives sharp focus from a metre or two to infinity although a tripod might be necessary to permit this.

This picture's composition conforms to the rule of thirds. The right side of the picture is dominated by the two standing rocks and these lead the viewer into the picture.

The dramatic sky complements the image. A clear blue sky goes almost black on infrared film and this would be over-bearing in this case. Similarly, a cloudy day would have given a dull, tonally flat sky.

▲ Fact file 2 | Palms at Furnace Creek | Death Valley National Park | California | USA | Will Cheung | Kodak's High-Speed Infrared film gives gritty results with high contrast, harsh tones and obvious grain. It does not suit every subject but its graphic nature does impart a very special character on the subject.

accessories

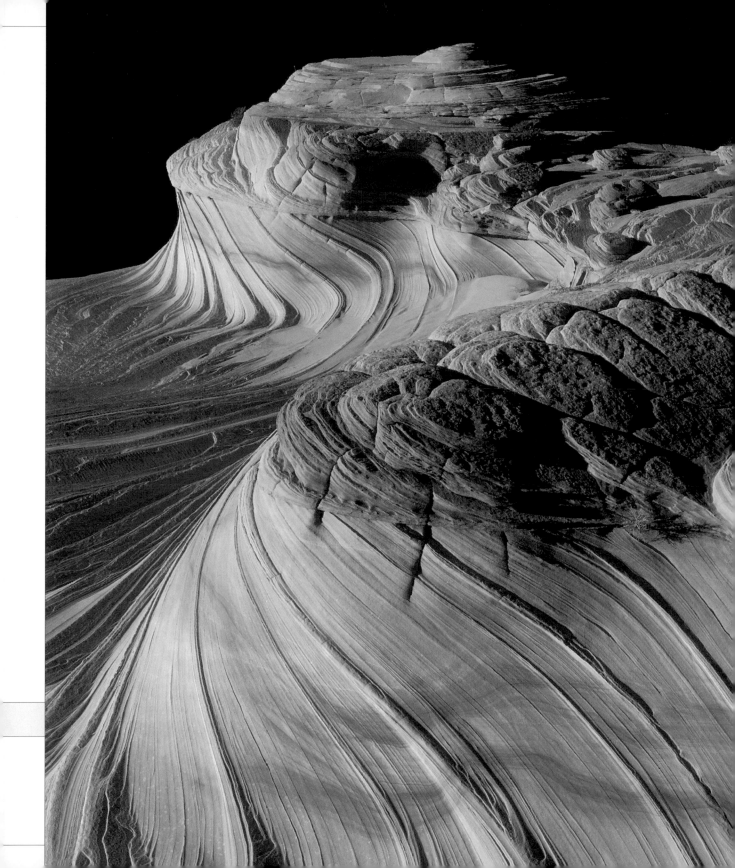

Photographer: Andy Piggott

Location: Nice, France

Conditions: Late winter's evening

Camera: Canon EOS 100, lens: 70–210mm at 135mm setting, film: Fuji Superia 100, exposure: 1sec at f/11

tripods long shutter speeds

Composition	Colour
I arrived in Nice late one winter's evening. I just had time for a walk along the sea front. There were blue chairs scattered all along the beach. They looked abandoned and forlorn. I looked for a nicely composed group. I did not move them, they were just there.	The chairs were lit by sodium lamps so I decided to shoot them on colour print film so that I could filter out any colour cast afterwards. Not only that, I did not have the right filters at the time to remove the colour cast that would have shown on slide film. Most films are designed for use in natural light so exposing the film in artificial light can give strange and sometimes unpredictable colours. The human brain sees scenes and makes everything look correct, but film does not work like that. It is sensitised to respond to particular light wavelengths and is unable to alter its response characteristics when faced with conditions it is not designed for.

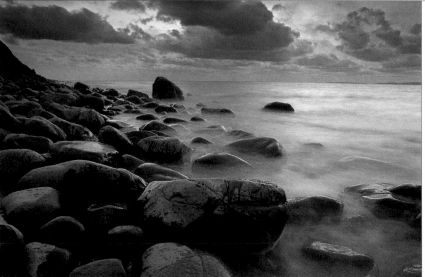

◀ Fact file 2 | Here Today, Here Tomorrow? | Harlech Beach | West Wales | UK | Dave Newbould | Using very long shutter speeds for moving water gives a lovely soft effect. For this shot, the photographer gave an exposure of ten seconds to create the ethereal effect and stopped down to f/16 for extreme depth-of-field.

Technique

It was late so I had to rely on artificial rather than natural light, the lighting levels were low so a slow shutter speed was needed. It was a question of how slow without risking camera shake and still capturing what I wanted. My tripod was back at the hotel so I used my trusty beanbag placed on a post. I took a number of shots at various shutter speeds and this one was the one second exposure. I wanted to get a creamy feel to the waves behind the chairs.

Camera tip

Faced by a poorly lit scene, the support is a tripod. But, of course, life is never as simple as that and you might not have a tripod with you, which is when you have to improvise. It might be as simple as leaning the camera against a convenient wall or resting it on a rolled-up jacket. Then gently hold your breath as you make the exposure.

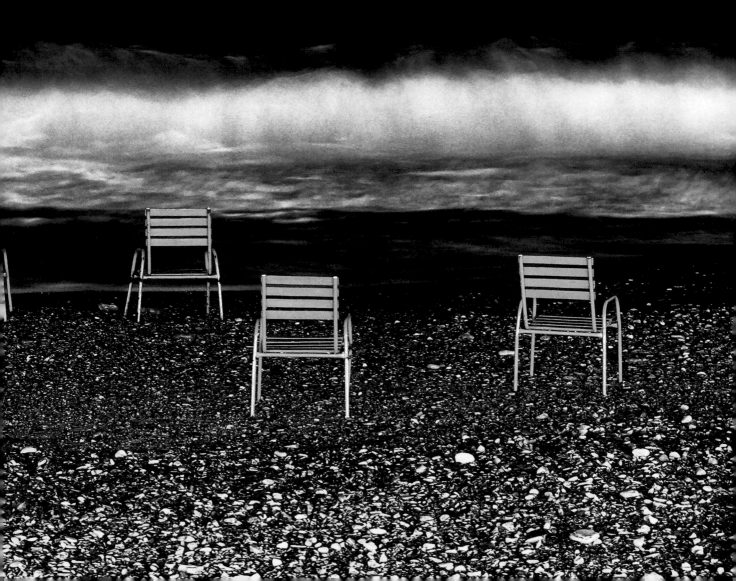

Photographer: Phil Handforth

Location: Hutton Roof Crag, South Lakeland, Cumbria, UK

Conditions: Bright day and early in the morning so the sun was low, giving a soft light

Camera: Mamiya RZ 67 Pro II, lens: 110mm, film: Ilford Delta 400, developer: Ilford ID-11, exposure: 1/30sec at f/22, camera on a tripod, no filter

Camera tip

Maximise the stability of your tripod by weighting it down with your camera bag draped across the tripod's shoulder. The extra weight will increase overall stability. One thing to watch is that the bag does not swing around and bang against the tripod's legs which will compromise stability.

using a tripod depth-of-field

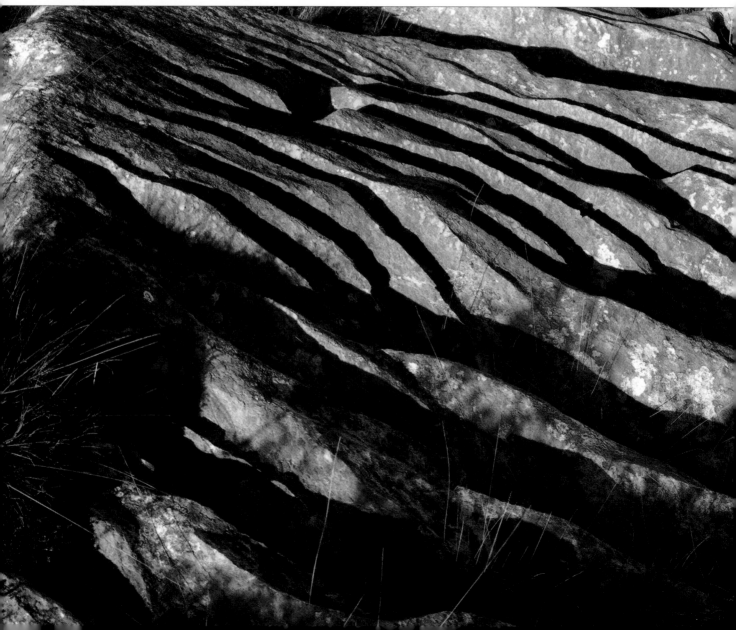

◀ Fact file 2 | Ivy and frost | Whittington | Lancashire | UK | Phil Handforth | The amount of depth-of-field decreases as you move in closer to a subject. Therefore, focusing and aperture choice are even more critical than normal. Set the smallest lens aperture you can and use the camera's depth-of-field preview feature to check what is in focus.

Concept

It was early morning and the sun was low enough in the sky to create this side-lit effect on this beautiful limestone pavement. I was keen to encourage the viewer to question what the picture was all about. Therefore, the overall effect is one of abstract anonymity.

Composition

Successful landscape pictures can be had right down at your feet. It is all about developing the skill of spotting and isolating unusual images within the wider scene. I was walking along when I saw this bold pattern of diagonal lines picked out by the morning sun. There is no obvious focal point but the picture here works because of the regularity of the repeating pattern.

▼ Fact file 3 | Yew and ivy | Carnforth | Lancashire | UK | Phil Handforth | Buy a tripod that suits your needs. Some models can go very low or have an innovative leg design that suits those keen on nature photography.

Technique

To most photographers the most important accessory is a stable tripod. It supports the camera to guarantee excellent picture sharpness, yet it gives you total freedom with choice of lens aperture and shutter speed. An additional benefit is that using a tripod slows you down and encourages you to explore the composition more thoroughly. The light of an early morning sun is relatively weak so a slow shutter speed was required in order to allow a small lens aperture for the maximum depth-of-field so the whole scene was sharp.

One of the elements working successfully in all of these images is the use of texture in the composition. Diagonal, vertical or patterned lines create strong movement in the images.

Fact file 1: Valley of Fire State Park

Photographer: Will Cheung

Location: Valley of Fire State Park, Nevada, USA, 35 miles north east of Las Vegas

Conditions: A cloudless blue sky had prevailed throughout the day

Camera: Nikon F-801s on a tripod, lens: 24mm lens, film: Fuji Velvia, filter: polariser

filter fun polarising

Polarising filters are used to control reflections off water, glass and other non-metallic surfaces. This pair of shots shows how a polariser changes the scene. Without the polariser all you can see is the sun glittering off the stream. Fit a polariser and rotate it to eliminate the sun's highlights and you can see through to the stream bed. The camera's meter reading was used unadjusted.

Colour

I had spent most of the day at the Valley of Fire State Park but without much photographic success. The sunlight was too harsh for interesting pictures. But as the sun descended in the sky and the warm light got even warmer, the naturally vivid red rock formations gained an amazing vibrancy and richness. This, in combination with a rich blue sky gave this powerful landscape, which is full of saturated colours.

Composition

Bold, plain compositions can have the greatest impact. I wanted a potent lead-in to take the viewer's eye into the picture, so I moved the camera position around until I got that strong diagonal line of the rock formation and sky coming in from the top left. That bank of rock also has lots of detail to attract the eye.

◀ Fact file 2 | Cumbria | UK | Will Cheung | An intense blue is not always needed so remember that the polariser's effect is progressive and check the effect in the viewfinder.

Camera tip

With the camera on the tripod, a cable or remote release is ideal for triggering the shutter without causing blurred pictures. But if you do not have one handy, simply use the camera's self-timer so that you are not touching the camera when the picture is taken.
Many models let you vary the delay time from the usual ten seconds. Check the camera's instruction manual for details.

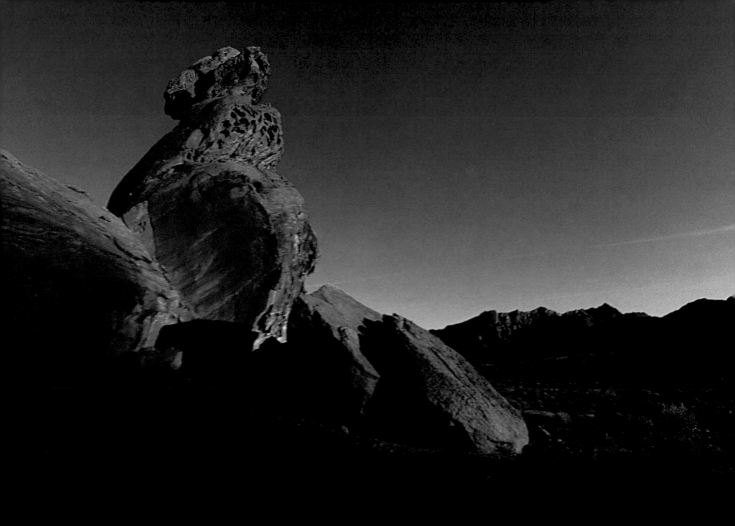

Technique

Getting out of the car, I had speedily set up the tripod and took several shots from a variety of angles, and was contemplating my next move. I took a polariser filter out and held it up to my eye and rotated it to examine the effect. Doing this saves time as opposed to putting it on the lens to check the filter's effect. Seeing that there was a benefit I fitted the polariser and adjusted it until I got the richest sky, then took a meter reading using the camera's selective measuring mode off the red sandstone. To enrich colours further I closed down the lens by an extra half a stop to deliberately underexpose the scene slightly.

Polarising filters do a great job of making a weak blue sky bolder and richer. But it is possible to overdo this and make the sky unnaturally intense. Take this example, which was shot mid-morning in Mykonos, Greece. On slide film, an exposure reading was taken off the white roof with the polarising filter in position. The result is a very dark sky which is too saturated. A non-polarised shot would have given a more viewer-friendly result.

Fact file 1: Sunset Pinnacles

Photographer: Tom Till

Location: Nambung National Park, Western Australia

Conditions: Sunset on a calm evening

Camera: 5x4in camera, lens: 90mm wide-angle, film: Fuji Velvia, filter: Lee 0.9 grey graduate, exposure: 8secs at f/3

using filters grey graduate

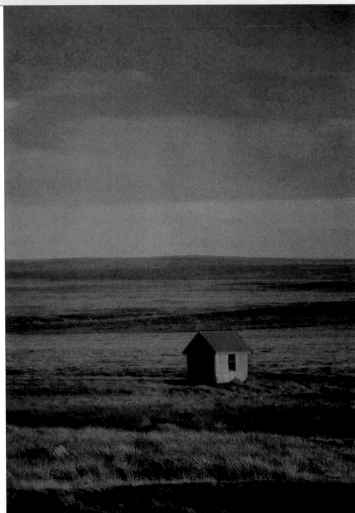

Colour

This photo is what I call an 'anti-sunset'. The phenomenon occurs when the sunset is opposite the setting sun in the eastern sky rather than in the west. It doesn't happen too often and I was very lucky. I had already spent a week at this location and had counted on this spot for just such an event. The sand's orange colour is really remarkable and there are tens of thousands of free-standing rock pinnacles in the area. I used the Lee 0.9 grey graduate filter to balance the light values between the brighter sky and the somewhat darker landscape.

◀ Fact file 2 | Angler's Hut | Caithness | Scotland | UK | Geoff Doré | Accurate positioning of the graduate filter is important and this can be checked by using the camera's depth-of-field preview feature. The choice of lens aperture also affects the filter's impact; the smaller the aperture the more obvious the change from the coloured to the clear area.

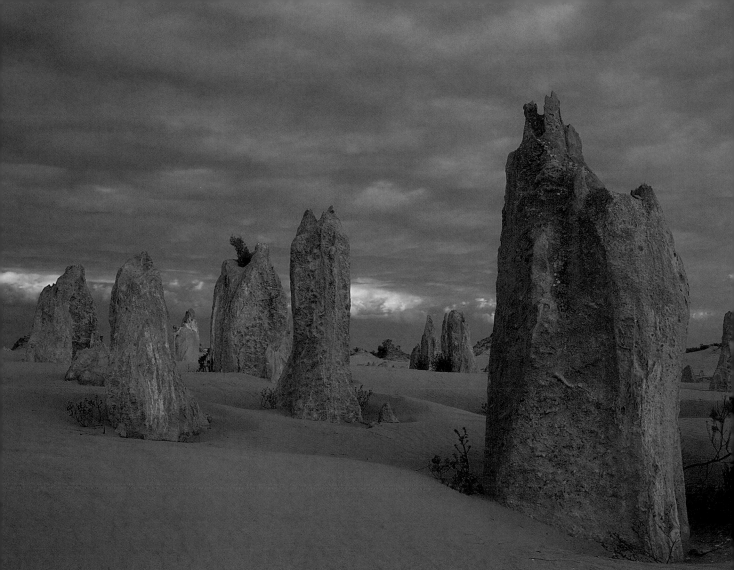

Composition

Wide-angle lenses need considered use for photographs with impact. It is a common failing with inexperienced users to stand too far away from the subject and leave areas of blandness around the main subject. To make the most of wide-angle lenses get in close and use part of the scenery to catch the viewer's eye and lead them into the picture. By selecting a small lens aperture it is possible to record everything from a metre or so to infinity in sharp focus.

Technique

Graduate filters add colour to an area of plain tone or can be used to cut down the amount of light from an area of extra brightness. These filters are clear at one end and increase in density towards the opposite end. Among landscape photographers, the three most popular graduates are neutral grey, blue and warm-up or orange. The darker area of the graduate will tell the camera meter to give more exposure, which would negate the impact of the filter. Therefore, metering should be conducted before slipping the graduate filter into position. With manual metering this is easy, but with autoexposure modes use the memory lock to memorise the reading before placing the filter.

Camera tip

Graduates are mostly used to add colour or control the contrast in the sky, but turn them the other way up and they can also be used to enhance the foreground. A popular colour for this is a warm-up or faint orange graduate which can add a friendly hue to a cool-toned foreground.

Fact file 1: Tree Parade

Photographer: Chip Forelli

Location: Po River Valley, south east of Milan, Italy

Conditions: Mid-morning, hazy sun, light seemed to come in from many angles highlighting the geometry of the lines of trees

Camera: Hasselblad Flex Body on a tripod, lens: 60mm set to f/16, film: Kodak T-Max 100 film, filter: green to lighten the foliage

filters lightening tones

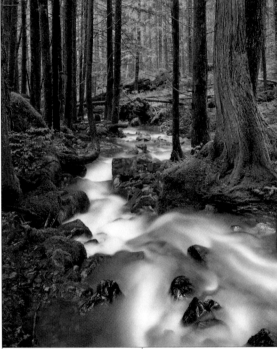

▲ Fact file 2 | Stream through Forest | North Cascades National Park | Washington | USA | Lynn Radeka | Coloured filters absorb light so also come in useful when you want to set longer shutter speeds for deliberate blur effects.

Concept

With the geometric layout of the trees and the weak sun filtering through the trees, I knew the scene had a great deal of picture potential. I was looking for a viewpoint where the contrasting brilliant foliage and dark edged tree trunks repeated to almost infinity creating a surreal environment for the viewer to walk through.

Composition

My biggest challenge was to find a camera position that presented a break in the predictable pattern of trees. I spent quite a lot of time moving around looking for what I thought would be the best viewpoint. I could see that the light would be fairly stable during this time so I knew there was not a major rush.

I finally found a position for my camera that presented a row of trees ending abruptly in the far distance.

Camera tip

Use converging verticals. Tilt a camera upwards to include the tops of trees and buildings means they will suffer from converging verticals and will appear to be falling over backwards. This is actually a strong compositional effect and can work really well with a wide-angle lens. If you prefer to avoid them, you need to keep the camera back as upright as possible. This might mean moving further from the subject or gaining a higher camera viewpoint.

Technique

Contrast filters are important in black-and-white photography and always worth using to modify the tonal range of a scene. A filter of one particular colour will lighten subjects of a similar colour while darkening other colours. A green filter was used for this picture and this has ensured that the grass and leaves have stayed relatively light-toned.

The use of the f/16 lens aperture has given ample depth-of-field so everything from the nearest tree to the furthest one are rendered sharp.

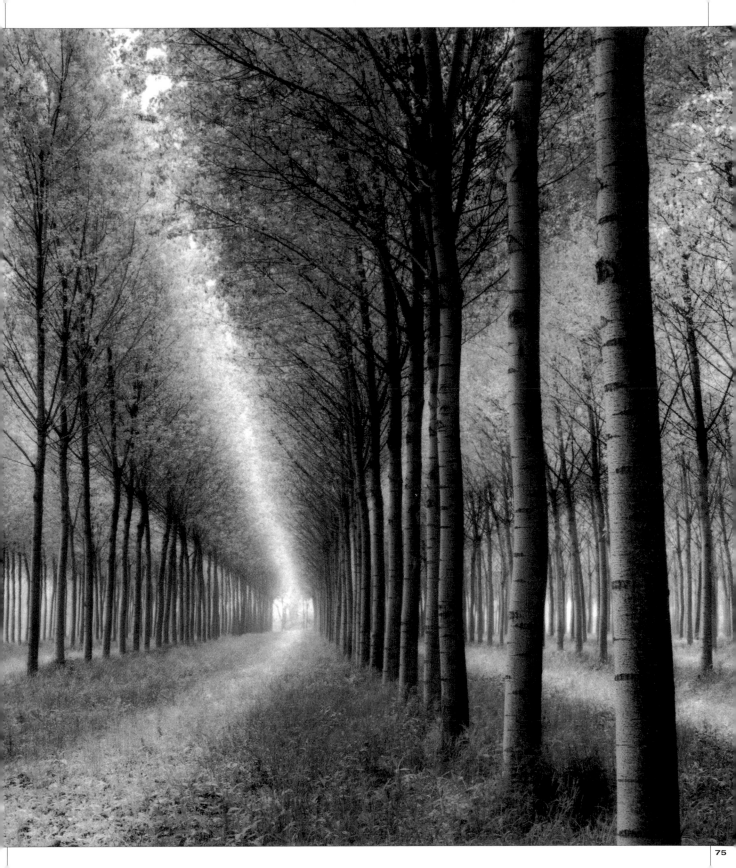

Fact file 1: Stormy Day

Photographer: Will Cheung

Location: Dunwich, Suffolk, UK

Conditions: Stormy autumn day, late morning. The sky was changing very quickly

Camera: Nikon FE2, lens: 20mm, film: Kodachrome 64, filter: Cokin P pink, camera hand-held

▶ Fact file 2 | Castell y Gwynt | Snowdonia | Wales | UK | Dave Newbould | Graduates can be used at all sorts of times. This picture was taken at dusk on a very cloudy day and a grey graduate filter helped to intensify the sky's colour while letting all those rocks in the foreground show.

using filters control the sky

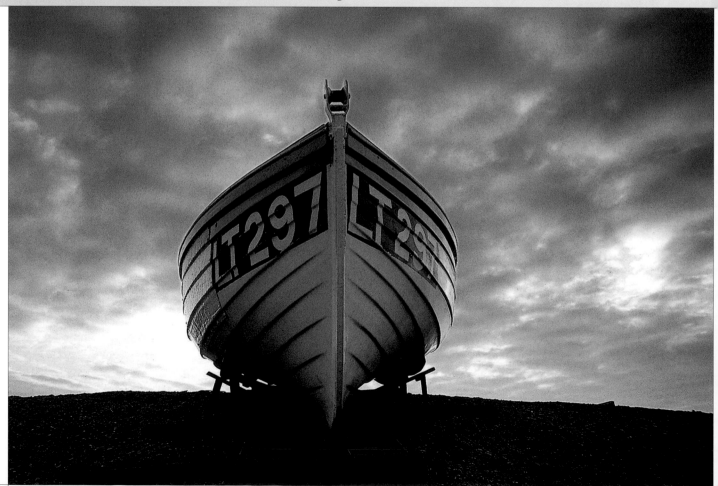

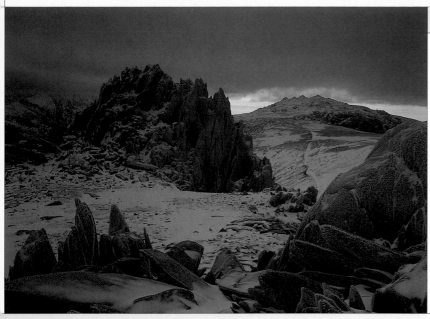

Technique

Landscape photographers use graduate filters to intensify a weak sky, or to enrich what is already there.

For a graduate to work effectively, it is important to meter the scene before slipping the filter into position. Take a light reading with the filter in place and the meter might be tricked into giving too much exposure which will cancel out the filter's effect.

Either take a manual meter reading or use the camera's autoexposure lock to memorise the exposure settings until you put the filter into place.

Once the filter is in place, move it up and down to ensure the right area is covered. It is worth also rotating the holder slightly too.

Camera tip

Use the camera's depth-of-field preview.

The strength of the graduation effect varies according to the lens aperture. Set a wider aperture such as f/4 or f/5.6 and the effect is smooth and gradual. Conversely, choose a small aperture of f/16 or smaller and the change in tone can be very severe and look unnatural.

Many cameras have a depth-of-field preview feature which closes the lens down to the value set on the lens and you can use this to examine the graduate filter's effect before taking the shot.

As you operate the preview button the whole image goes darker – the smaller the aperture, the darker the image goes. The key to using this feature well is to give your eye a few seconds until it is used to the dimmer image before making any sort of judgement.

Composition

While viewing the scene before taking the picture I can spend as much time looking at the background as the main subject. Inexperienced photographers will concentrate on the subject and forget the background, only noticing how messy it is when their pictures have come back from the processors.

Once you learn to do this so it becomes second nature, you will also become adept at automatically varying camera viewpoint. Moving left or right a metre or two, or crouching down can all dramatically improve a composition.

In this instance, I got very low down so that the buildings in the background were not even an issue for a cleaner, more effective composition.

Colour

I use filters to modify and control light. They are extremely useful accessories employed at the right times and with good technique will significantly improve your photographs.

Of course, adding filters has also reduced the scene's overall contrast. The scene ranges from the highlights in the bright sky to deep shadows under the boat.

Sensitised film cannot deal with such a contrast range, even if your eye can.

I wanted good detail in the fishing boat, but at the same time there was no way I wanted that wonderful sky detail to burn out.

I decided to use two graduate filters in combination, one grey to cut down the intensity of light and a pink to add some colour to the sky.

Fact file 1: Norfolk Windmill

Photographer: Will Cheung

Location: Cley-next-the-Sea, Norfolk, UK

Conditions: Sunny day without a cloud in the sky

Camera: Olympus OM-2n, lens: 17mm ultra wide-angle, film: Ilford FP4, developer: Kodak HC-110 1+31, paper: Ilford Galerie grade 3, filter: 8x Hoya red

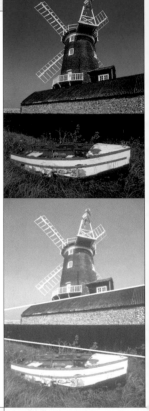

It was a beautiful day but the lighting was bland so there was the risk of an uninspiring colour picture.

Concept

This restored windmill is next to the main road so it is a popular photo opportunity. This was the second time I had driven to the area. The first time, it had been dull and rainy and the photo potential was limited. On this occasion, however, it was the complete opposite. It was hot, the sky was blue with the sun shining strongly and there were no clouds in the sky. In other words, it was a beautiful day, but the lighting was bland so there was the risk of uninspiring pictures as the colour comparison picture shows.

Composition

I wanted to do more than a snap so I walked around the windmill and came across this decrepit boat. It made for a perfect foreground. Wide-angle lenses demand the photographer to think about the foreground and I reckoned this boat was perfect for this purpose. There are strong thirds in this image. The foreground boat occupies the bottom third while the windmill itself is the focal point in the top third. However, the wall neatly divides the picture into two which some would say is something to avoid in compositions. Here, however, it works.

Technique

To bring some tone into an otherwise bland sky I fitted a 8x red filter. With ISO 125 I was getting an exposure meter reading of 1/60sec at f/8. No tripod was available so I could not set a smaller aperture for really extensive depth-of-field. But by using a 17mm ultra wide-angle lens I knew even at f/8 there would be good front-to-back sharpness, but I used the lens's depth-of-field scale to focus hyperfocally for maximum depth-of-field.

The red filter has darkened the grass and the sky which has helped the windmill and the boat stand out prominently.

The film was developed in Kodak HC-110 diluted 1+31 and the print made on fibre-based Ilford Galerie grade 3 printing paper. Because the red filter did such a good job of bringing in the sky tone no burning in of the sky was necessary, except in the extreme corners to give a print with more depth. An extra half a stop of printing exposure was also given to the foreground boat. This darkened the grass even more but also revealed more highlight detail in the boat to lead the viewer into the picture.

using filters contrast

◀ Fact file 2 | Victoria Peak | Hong Kong | Will Cheung | Orange and red filters help cut through atmospheric haze to reveal distant detail. A blue filter would accentuate any haze. Here, a wide-angle lens was used to include the foreground which provided a solid base on which the picture could rest.

The boat occupies the foreground – while the windmill itself is the focal point in the top third.

Using red filters

Red contrast filters need to be used with care. With a strong blue sky, a red filter can make it unnaturally dark and unless you are specifically after a demonic sky, this can be too strong. If you prefer a more subtle sky effect, an orange or yellow/green filter is advised.

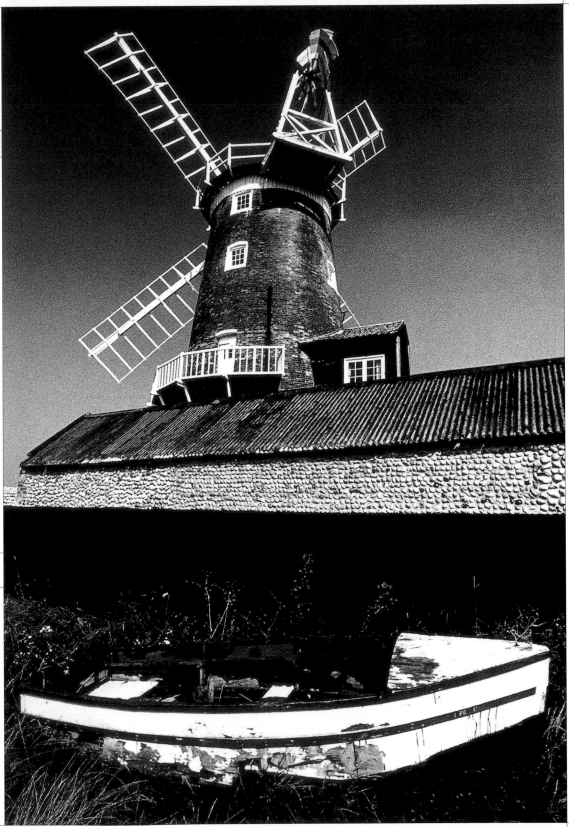

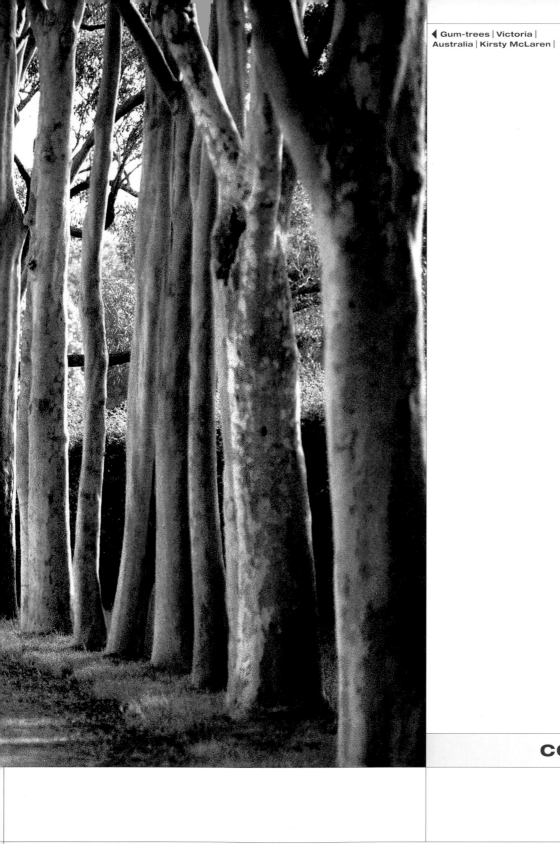

composition

Fact file 1: Climbing Uluru

Photographer: Andy Piggott

Location: Uluru (Ayers Rock), Northern Territory, Australia

Conditions: Bright early morning

Camera: Canon EOS 100, lens: 70–210mm at the 200mm end, film: Kodak Ektachrome 100, exposure: 1/250sec at f/11

Colour

Uluru has many moods, the intense colour of the rock changes through the day. As you walk around the base it is easy to understand the attachment that the local Aborigines feel to this place.

The early, relatively low sun has revealed texture as well as given the rock a warmth which went soon after this picture was taken, replaced by a much cooler, harsher light.

how to compose scale

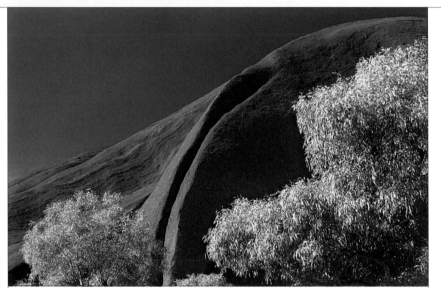

▲ Fact file 2 | Uluru | Northern Territory | Australia | Andy Piggott | A different interpretation of the same location. The photographer wanted to show the shape of Uluru and this time avoided any people so the sense of scale is less immediately obvious. This was taken on a Canon EOS 100 with a 35–105mm lens at about 85mm. The exposure was 1/350 second at f/11 on Kodak Ektachrome ISO 100.

Camera tip	Composition	Technique
Landscapes with a warm hue are much more welcoming than those with blue colour cast. This explains why professional landscape photographers love the 81 series of warm-up filters. The series is available in different strengths from the 81A, the weakest, to the 81EF which gives the strongest effect. For general all-round use go for the 81B.	After travelling through the mainly flat Australian outback, Uluru (Ayers Rock) looms large. This shot was taken early in the morning and shows the first of the day's tourists climbing the rock. I was aiming to show the scale and grandeur of the rock, and using the figures across the top does this. The strong diagonal line which runs from one corner to another is very effective and gives the composition a great dynamism.	Generally speaking, the best light for landscapes happens early in the day or late. The hours in between when the sun is high in the sky gives a harsh light that can make scenes look too contrasty. The high sun also seems to 'flatten' scenes so pictures appear to lack modelling.

Fact file 1: Sunset, Grandview Point

Photographer: Lynn Radeka

Location: Grandview Point, Canyonlands National Park, Utah, USA

Conditions: Sunset after a big thunderstorm

Camera: Super Cambo 5x4in, lens: 121mm, film: Kodak Ektachrome

Colour

Being out there in unpromising weather conditions can reward the enterprising photographer. I took this after an exciting thunderstorm when there was a sudden break in the clouds which gave this extraordinary light. It seemed to bathe the deep-cut canyons of Canyonlands National Park in gold. I quickly seized the opportunity to expose two sheets of 5x4in film before the wonderful moment vanished forever. Photographs of this nature are easily captured by the prepared photographer who practices their craft regularly so that inspiring moments can be captured more instinctively than consciously.

Composition

One compositional rule that works time after time is the rule of thirds. Just imagine that the viewfinder has two lines running across and down the image dividing the scene in equal thirds. Use it by placing the horizon along one of the lines or composing so that the focal point of the scene rests on one of the intersections. It is a rule that is very effective and easy to apply so if you are new to landscape photography, learning to use it will improve your scenic pictures.

Camera tip

Getting used to your camera so you can react instinctively to catch magical moments is definitely worthwhile. With an unloaded camera, try focusing, adjusting modes and generally getting used to its control layout. But being familiar with the camera's physical attributes is only part of this process and you should regularly practice taking pictures too so you can predict how the camera behaves in difficult lighting conditions.

how to compose rules

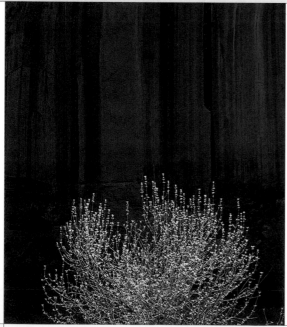

◄ **Fact file 2 | Bush and Cliff | Capitol Reef National Park | Utah | USA | Lynn Radeka |** The so-called 'rules' of composition should be used as guides, especially by inexperienced landscape photographers. However, once the rules are understood it is often worth ignoring them for stronger compositions.

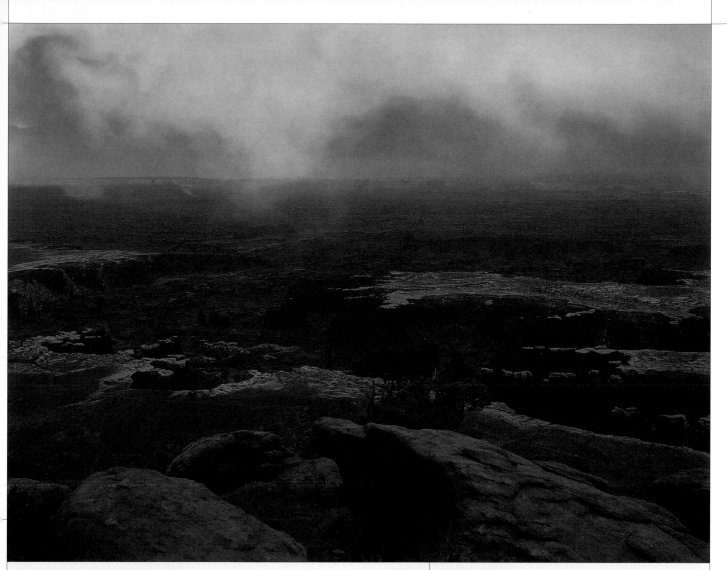

Technique

In once-in-a-lifetime opportunities it is worth exposing several pictures to ensure you get a good result. It is not worth skimping on film on such occasions. Taking several shots at different exposures around the metered reading is known as 'exposure bracketing', and although it seems wasteful of film, it does at least guarantee a perfect result if you are uncertain of the exposure. How much you bracket depends on the film. With a print film which has relatively good exposure latitude, it is worth bracketing in full stop steps while with slide film, plus or minus half a stop is fine. With experience you will find that you do not need to shoot above and under the meter reading, but either shoot two shots both under or both over. This comes with practice as you learn how the camera reacts to different lighting situations.

Placing the horizon across the centre of the picture frame is best avoided. It can result in very dull compositions. Composing so that the horizon runs along either the top or the bottom third is much more effective. Which option to go for depends on the scene. To make more of the sky, place the horizon on the bottom third while the other option is great for strengthening the impact of the foreground.

Fact file 1: Keanapuka Arch	Colour
Photographer: Tom Till	Thanks to the composition the eye is led immediately from the detailed but cool-toned foreground to the intense greenness and warmth of the distant hill. The sky and clouds add an essential element of balance. Imagine the sky as just blue or bland grey and you will realise its importance to the success of this photograph.
Location: Sea arch in among the sea cliffs on the island of Molokai in the US state of Hawaii. Picture taken at low tide	
Conditions: Sunny, late spring day	
Camera: Toyo 5x4in, lens: 75mm wide-angle, film: Fuji Velvia, exposure: 1/4sec at f/45	

▼ Fact file 2 | Poplars | Murray Valley | Australia | Andy Piggott | Compositional frames can come in many different forms. Repeating lines such as these poplar trees do a great job of pulling the viewer into the picture. Diffuse lighting has avoided any distracting heavy shadows.

how to compose framing

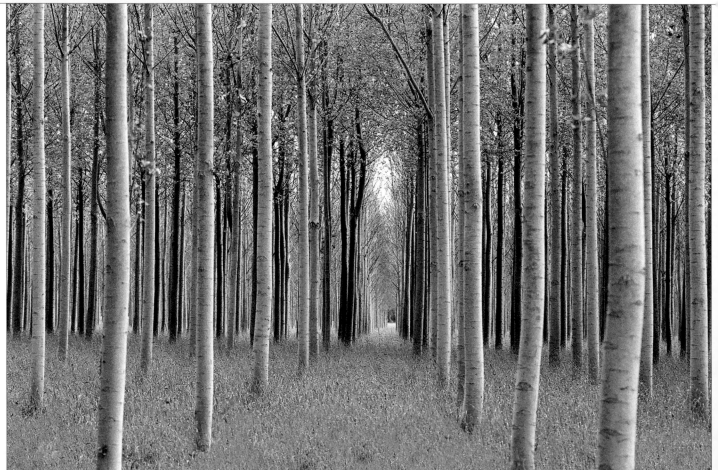

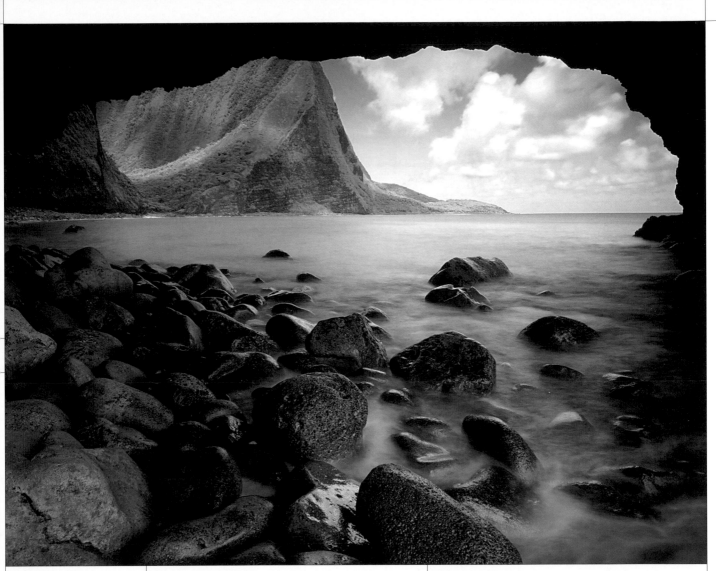

Camera tip

Most SLR camera viewfinders only show 90-95% of what will come out on film, with only a very few professional models showing 100%. Unless you make your own prints, this is no disadvantage and should not hinder the accuracy of your compositions. Bear in mind that the printing machines in use commercially or the mounts used to hold slides automatically crop off part of the image anyway.

Composition

Landscapes often benefit from a 'frame' which helps hold the viewer's attention in the photograph. Natural frames can take a variety of forms. It can be as simple as some overhanging branches, the span of a bridge or something unusual like the roof of a cave.

These cliffs are the highest sea cliffs in the world and this cave is only accessible by boat during the summer. I was dropped by boat and spent several days hiking in the area, and I had to pass through the sea arch at low tide to get anywhere. This image was taken inside the arch at low tide and it forms a superb natural frame which holds the viewer's attention incredibly well.

Technique

Using a natural frame to enhance your pictures can throw up exposure headaches which need careful handling. The darker regions can fool the meter into overexposing the subject. To avoid any problems engage the camera's selective or spot metering mode to ensure the light from the subject is measured. If the contrast is too great, consider using a grey graduate filter, carefully placed over the brightest area to stop it being overexposed.

Fact file 1: Rannoch Moor

Photographer: Peter Clark

Location: Rannoch Moor, Scotland, UK

Conditions: Midday, October

Camera: Canon EOS 1, lens: 24mm, film: Ilford FP4+, filter: red plus a polariser, developer: Ilford ID-11 1+1, paper: Ilford Multigrade at grade 4 1/2

▼ **Fact file 2 | Three trees | Jericho | Long Island | New York | USA | Chip Forelli |** This long exposure of the trees was a night picture taken in a field adjacent to a brightly lit football ground. The main tree dominates the frame but it is the intriguing nature of the image that makes the central composition work.

how to compose using a central focal point

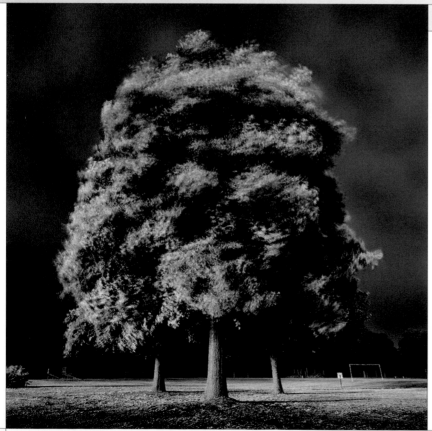

Concept

The isolation of a lone ragged tree set in the vastness of Rannoch Moor provided my inspiration for this image. I tried to take this picture earlier in the year around February but it was not successful because the patchy snow on the distant hills was distracting, there was too much grass around and the burn was too full of water. Which is why I went back in the autumn.

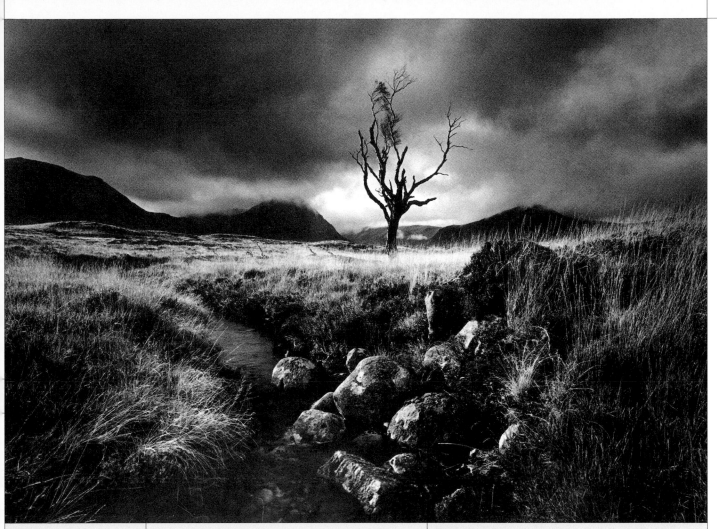

Camera tip	Composition	Technique
Keep your filters clean. Marks and dust can cause flare as well as affect picture sharpness. Cleaning should be done carefully with a blower brush and a micro-fibre cloth and filters should be returned for safe-keeping to their wallets or cases after use.	This image shows that you can successfully break the rule of not placing the main subject in the centre. I did try placing the tree at different positions within the composition but it worked best here. The stream leads the viewer into the scene by way of the rocks while the heavy sky and dark hills on each side help to concentrate attention on the main subject.	Sometimes using just one filter is not enough and you may need two to achieve the affect you want. This is what I did here. The polariser can be used as a neutral density because it absorbs light without affecting colour reproduction, but used in combination with a red filter it helps to give extreme contrast and a blue sky can almost go black. It is a dramatic effect but should only be used if you want a stark, very graphic effect.

Fact file 1: Kildrummy Castle

Photographer: Hans van der Pol

Location: Kildrummy Castle, Scotland, UK

Conditions: It was a grey, cloudy and wet afternoon

Camera: Nikon F90, lens: 20mm, film: Kodak Tri-X, filter: red, camera hand-held

Concept

The stones in front of the castle are not what they seem. In fact, it is a brick wall surrounding the area around the castle. By sitting on the ground for the lowest possible camera position I managed to use the wall as a foreground. I had noticed that the sky comprised two distinct cloud layers, the highest solid dark grey and below some smaller fluffy clouds. I used a red filter to make the difference much more visible on film. In the darkroom I had to give a lot more extra exposure to make the clouds bold.

Technique

Successful use of wide-angle lenses often means careful choice of viewpoint, particularly to make the use of bold foreground detail to add interest to the picture. Moving around, varying camera angle while checking the effect in the camera viewfinder is a technique always to consider. Here, this technique showed that a low camera angle gave the most effective composition with the lines of the wall taking the eye to the distant castle.

Camera tip

While sports photographers use monopods to support their long lenses, comparatively few landscapers use them. But in fact they are very useful gadgets and provide good support even down to shutter speeds of 1/8 second or slower. Besides, as monopods are basically just one leg of a tripod they are lighter to carry, quicker to set up and even do as a makeshift walking pole.

how to compose camera viewpoint

◀ **Fact file 2 | Clifden Castle | Scotland | UK | Hans van der Pol |** Pointing any wide-angle lens upwards results in converging verticals where buildings, for example, appear to be leaning backwards. Keep the camera parallel to the subject if you want to avoid this effect.

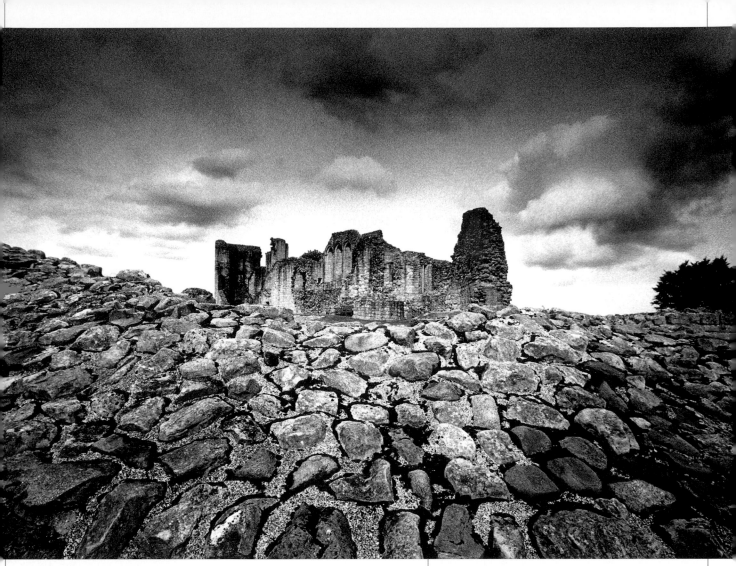

Composition

The wall and the sky with its darkened corners almost force the eye into the picture and the castle ruin. Putting the main focal point right in the centre of the picture can cause a picture to look unbalanced but it works well in this composition. Getting down low to make the most of the foreground gives the whole image a solid base on which to sit.

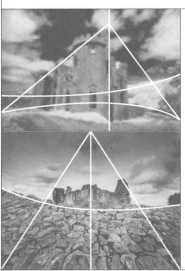

Small changes in camera viewpoint can have hugely significant benefits to compositions. Getting lower, for example, can make a bold foreground even more potent. Altering camera viewpoint can also stop common elements like telegraph poles, people and cars adding to a cluttered background.

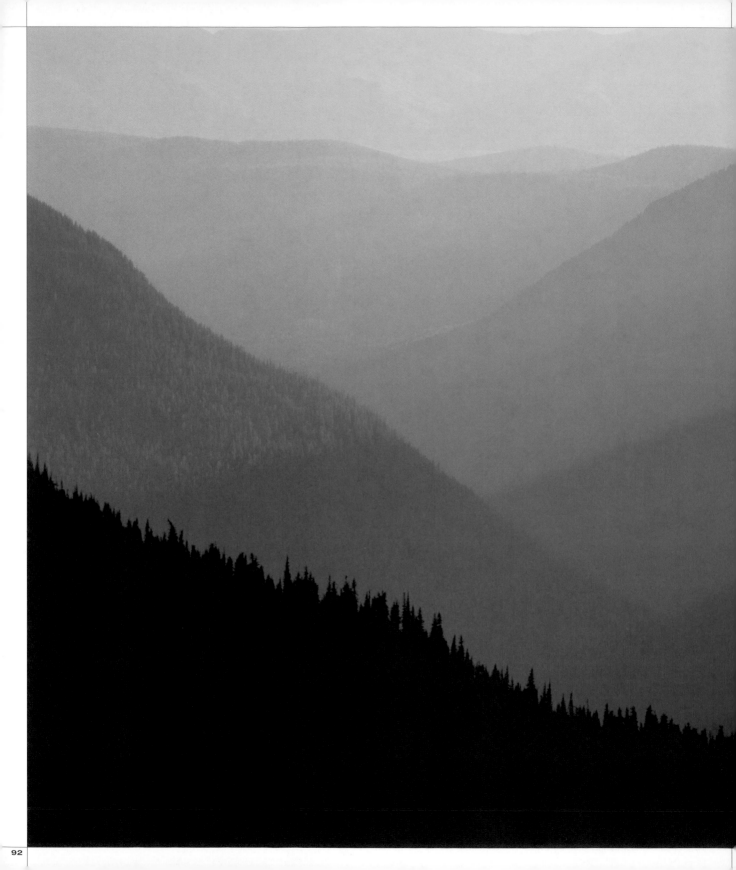

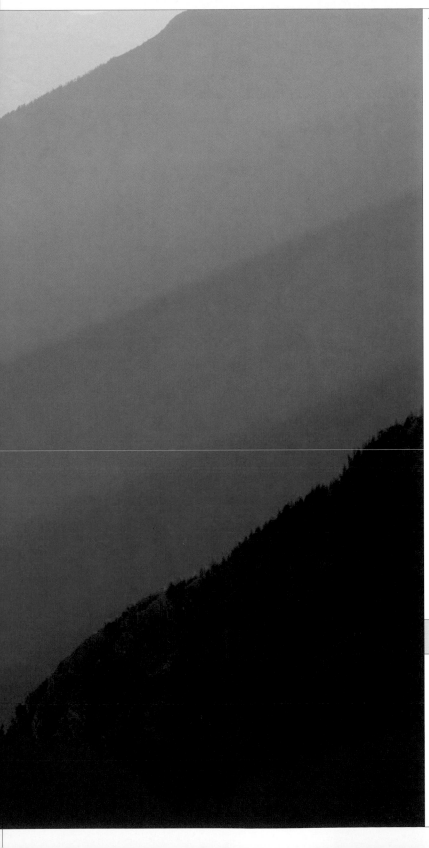

time of day

Fact file 1: First Light on Dunes

Photographer: Alain Briot

Location: Dune field east of Chinle, Navajo Nation, Arizona, USA. I had been there several times in the past and knew the place well, but I had never photographed there at sunrise

Conditions: I got there very early while it was still pitch black and started hiking blindly into the dunes

Camera: Linhof Master Technika 5x4in, lens: Super Angulon 75mm f/5.6, film: Fuji Velvia, no filter, camera on a Gitzo Mountaineer carbon-fibre tripod

time of day starting early

Colour

There was no moon that night to help so I could not see where I was going. I was concerned about walking in the delicate sand ripples because I would have ruined them, so I was extra careful about where I went.

As the dawn got lighter, I suddenly realised I had to set the camera up and take the shots before the sun arrived and bathed the dune field in light. I thought this would ruin the mysterious transition and those marvellous colours between day and night that I wanted to capture.

Composition

Bold foregrounds suit wide-angle lenses and one aimed slightly down at the dunes has given this potent perspective effect, pulling the viewer into the distant twin rock pillars. The strong lead-in lines created by the low angle of the sun also enhance the dominating effect of the foreground.

Technique

I had to imagine where the sun would rise and which parts of the dune field would get the first light. I stared at the sand ripples and realised that as the sun rose these ripples would be boldly defined. I positioned the camera and fitted an extreme wide-angle lens and composed the image so that the two large buttes, called Los Gigantes, would appear at the top of the frame towering over the dunes to give a near-far relationship. I could not calculate exposure precisely until the sun came out so I had to wait.

On my view-camera I tilted the lens forward slightly and focused on the hyperfocal distance, about one-third of the way into the picture.

When the sun came out I calculated the exposure with my Gossen Lunasix meter with a spot meter attachment and bracketed to compensate for any potential mistakes.

By the time I was done the mysterious effect of first light touching the dunes had vanished. When the shots came back from the processors I realised, ironically, that the best image was the very first one taken that morning.

Camera tip

For shooting when the lighting levels are really low, a pocket torch is worth its weight in gold. It will help you see what the camera settings are, see the meter reading on the hand meter or where that important accessory is in the gadget bag.

◀ Fact file 2 | Golden Hills | Marlborough Province | South Island | New Zealand | Matheson Beaumont | It is the repeating pattern of the sun-drenched fields that make this image so attractive to the eye. The use of a telephoto lens has compressed perspective to reinforce the pattern effect.

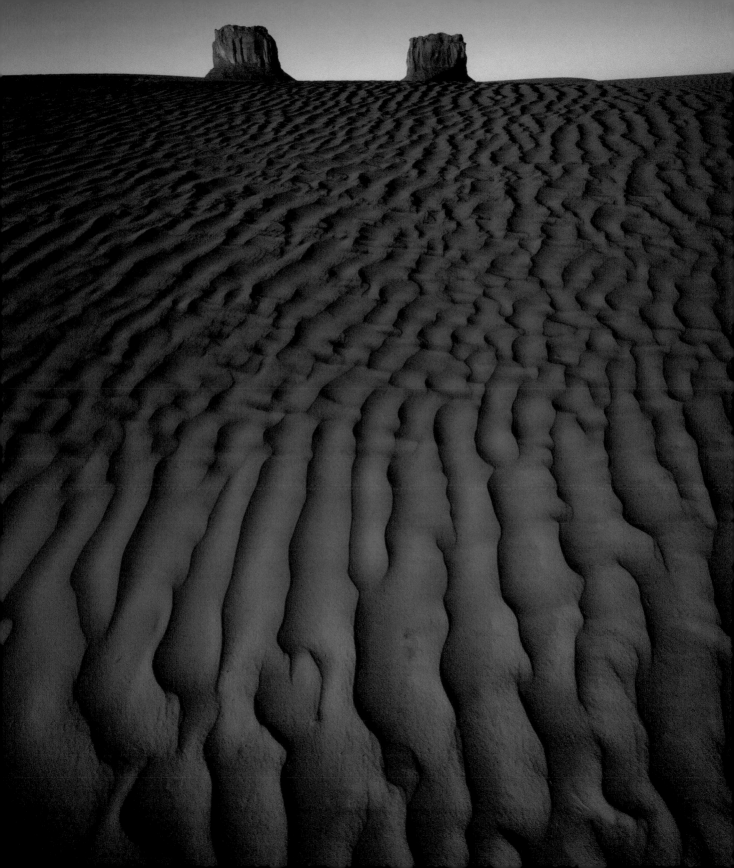

Fact file 1: Coniston Morning Mist

Photographer: Phil Handforth

Location: Coniston Water, Lake District, UK

Conditions: Early morning with mist quickly changing

Camera: Mamiya RZ 67 Pro II, lens: 150mm, film: Ilford Delta 100, developer: Ilford ID-11, exposure: 1/2sec at f/16

Camera tip

Keep horizons level:
A very useful accessory is a spirit-level which slips on to the accessory shoe of your camera. They are not expensive and help ensure that horizons in your picture remain accurate and level; really crucial when shooting scenes like seascapes. Some tripod heads have spirit levels built in too.

time of day early morning

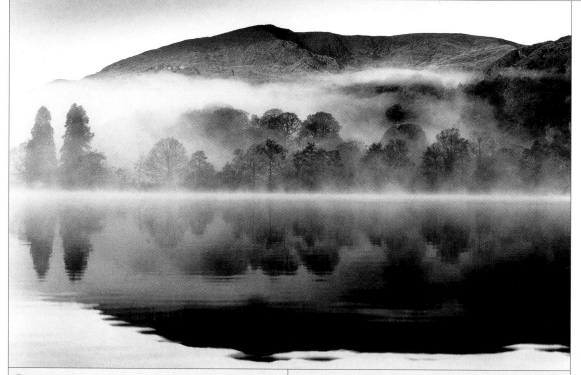

Concept

The main focus of the picture is the trees still veiled in the low mist while the mountain in clear view above gives the hard, well-defined edge which contrasts against the softer lines below. Finally, the dark shadow of the mountain is nicely balanced with the plain, light-toned sky.

Composition

There is limited thinking time when conditions are changing quickly, leaving no time to exchange lenses or play around with filters – the end result of such a composition becomes instinctive.

The solid line of mist running across the horizon gives a strong line which splits the picture into two separate zones. The result is a beautifully balanced composition with plenty of delicate detail for the eye to explore and enjoy.

Technique

Unusual weather conditions rarely last long so it is important to be there at the right time and to shoot quickly. This was a lovely morning and the conditions were changing rapidly as the sun was rising and quickly burning off the mist that had completely shrouded the trees just minutes before. I wanted to achieve this 'transition' from misty to clear in the one photograph.

I took an average meter reading and then opened up by one stop, this extra exposure giving the luminosity in the mist that I wanted to capture and the mystique that surrounds the area.

▼ Fact file 2 | Angel Arch | Canyonlands National Park | Utah | USA | Lynn Radeka | There is a crispness to morning sunlight that imparts a lovely freshness to the landscape. Conditions do change quickly so learn to seize the moment and shoot quickly.

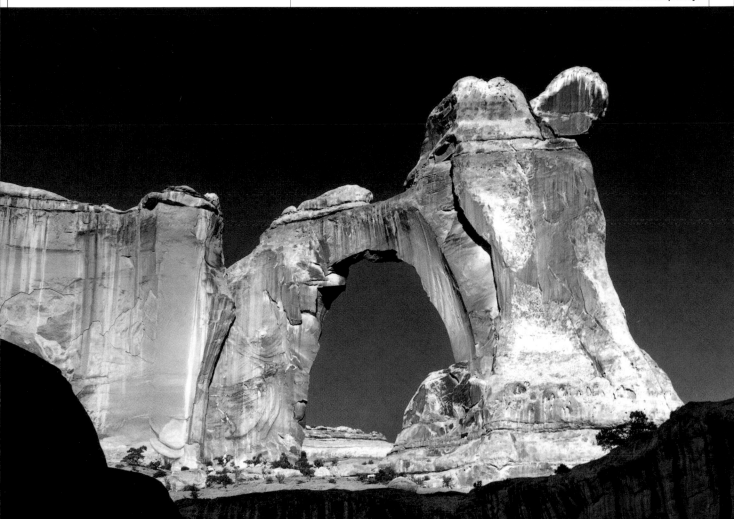

Fact file 1: Snowdon Sunrise

Photographer: Dave Newbould

Location: Looking at Snowdon from the roadside at Llanfair, North Wales, UK

Conditions: About 8.30am on a very cold New Year's day

Camera: Minolta Dynax 700si on a tripod, lens: 70–300mm zoom at 200mm, film: Fuji Velvia, exposure: 4secs at f/27

time of day sunrise

Colour

During sunrise and sunset the sun gives a very warm light and this can make for attractive, very welcoming photographs exhibiting a stunning array of harmonious colour. Colours rapidly change at these times of day, which is why it is always worth shooting several photographs at short intervals in between to capture the many moods. In the case of a sunrise, the photogenic mood can disappear in a matter of minutes after the sun has risen over the horizon and bathed the scene with light.

Composition

I was on my way for a spot of winter mountaineering. Only about a mile from home I saw the rising sun having this amazing effect on Snowdon and I just had to stop to take it.

Using a telephoto lens has compressed perspective here so it seems that the mountains are close to each other.

Technique

Careful metering is needed to make the most of sunrises and sunsets. Many modern SLR cameras have a spot meter and this is definitely worth using during these contrasty times. But take care where you measure light from. Metering from the sun's disk will underexpose the scene while measuring light from the shadows will lose detail in the highlights.

Because of the extreme conditions, many photographers choose to 'bracket' their exposures, which means taking extra pictures at exposure settings above and below the metered reading to ensure at least one perfect exposure.

Camera tip

The key to successful sunrise and sunset pictures often has more to do with planning than camera skills. It is important to be in position, with all your kit set up and ready for the light because at the extremes of the day it is rapidly changing and you want to be ready to capture every subtle nuance. Furthermore, every sunrise and sunset is unique so there is always the potential for amazing, once-in-a-lifetime photographs.

Fact file 1: Dusk near Delhi

Photographer: Kirsty McLaren

Location: On the road to Agra, near Delhi, India

Conditions: Taken in the last moments of sunset before dusk. Lighting levels were very low and it was dusty too

Camera: Nikon, lens: 80–200mm f/2.8, film: Fuji Velvia rated at ISO 80 and push-processed one stop, exposure: 1/15sec at f/2.8, camera hand-held

Composition

There are several important elements in this picture: the hut, the sun and the right-hand tree. They combine effectively in this composition and there is no one dominant or outstanding element, but lose any one of them, and the picture would have been much weaker.

time of day late

Colour

I shot this photograph on the way back from the Taj Mahal on the Delhi-Agra road. I was extremely unwell from fever and stomach cramps, but I was desperate to get one last shot in the beautiful moments of this day. No filters were used but the low, warm light at the end of the day combined with the extreme pollution and dust helped give this scene vivid colours.

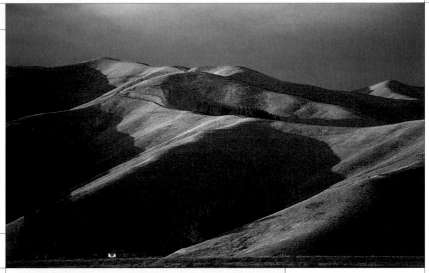

Camera tip

Most modern 35mm cameras have a feature called DX-coding to automatically set the correct film speed. Contacts in the film chamber 'read' the chequered pattern on the film cassette to set the correct ISO speed and the film's number of exposures. However, you might not always want to set the film speed designated by the manufacturer, i.e. when push-processing, so you should use the camera's manual ISO facility, if it has one. If your camera is DX-only with no manual override option, it is possible to buy DX recoding strips which stick on the cassette to fool the camera into thinking a film of a different speed is loaded.

Technique

In low light and in the absence of a tripod, there is the risk of camera shake. If you have faster film available that is less of a problem, but what if you only have one film speed? The answer is to rate the film at a higher ISO speed (known as uprating) and then give extended development during processing (known as push-processing) to compensate. For example, exposing an ISO 200 film at ISO 400 can make the difference between taking a sharp picture and a useless blurred one.

Not every film responds well to this technique, particularly colour print films, but it does work with transparency and black-and-white films. Such films can be push-processed one or even two stops without too much quality loss.

▶ Fact file 2 | Tassajaro Region | Contra Costa County | San Francisco Bay Area | California | USA | © Gary Crabbe | Mist, whether in the morning or in the evening, can give pictures an extra depth and using a telephoto lens can enhance this effect.

▲ Fact file 3 | Marlborough Province | South Island | New Zealand | Matheson Beaumont | The landscape changes significantly as the sun gets lower in the sky. The oblique lighting can produce plays of light that are very photogenic.

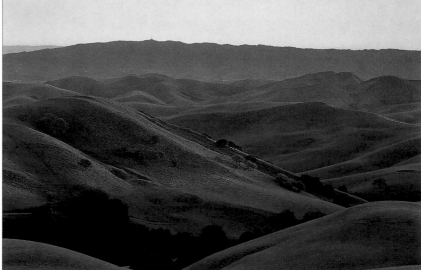

Fact file 1: Lake McDonald Reflections

Photographer: Tom Till

Location: Lake McDonald, Glacier National Park, Montana, USA

Conditions: Late in the evening on a very calm day

Camera: Toya 5x4in, lens: 210mm, film: Fuji Velvia, exposure: 1sec at f/32

Camera tip

Reflection pictures do throw up one focusing problem: do you focus on the reflection or do you focus on the reflected subject? In the example here, the reflection and the reflected subject are at a long distance so the answer is easy. But it is not always so straightforward. Selecting a small lens aperture to get maximum depth-of-field is one way to help, but even this might not be sufficient. Checking the camera's depth-of-field preview feature will help you assess this.

time of day shoot when the sun is low

◀ Fact file 2 | Moine Croft | Scotland | UK | Geoff Doré | As the sun gets lower in the sky, the light gets warmer and more photogenic. This warmth can be reinforced by using an 81 series brown filter.

Colour

My trip to Lake McDonald gave me some of the best pictures of that year. The light of this particular evening was awesome, with constantly changing patterns of sunlight playing on the foreground off-setting it against brooding skies. I thought here the blueness of the late evening sky complemented the warm light striking the distant shoreline. It was so intense no filters were needed to give this great result.

Composition

Running the horizon through the middle of a picture can give an unbalanced composition but it can work perfectly for reflections. There is great symmetry here and the lines of light running down the hillside are mirrored perfectly in the still lake. It is also those bands of colour that give the image energy and help pull the viewer's eye into this majestic scene.

Technique

It was a gorgeous evening and the light was amazing. The lake was also incredibly still, which I guess happens only once every few years. When faced with a scene like this, a camera meter can get it wrong. The predominately darker areas will cause the meter to overexpose very slightly and this can lose all the mood and atmosphere of a wonderful scene like this. If your camera has a spot or selective light measuring option, it is worth using it. Such modes let you measure light from small areas of the scene rather than taking an overall reading. Taking a spot or selective light measurement from the highlight areas will ensure they will come out accurately.

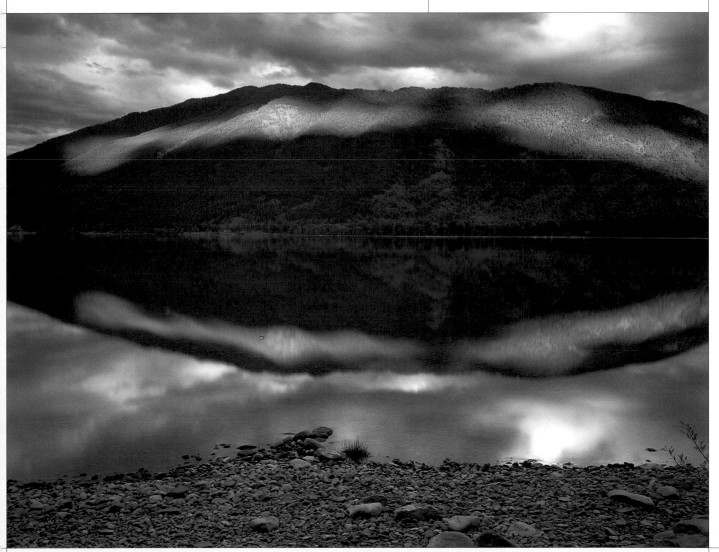

Fact file 1: Tree, Grand Canyon	Colour

Photographer: Tony Howell

Location: South rim of the Grand Canyon, Arizona, USA

Conditions: Sunset at the end of a clear day

Camera: Bronica SQ-A on a tripod, lens: 80mm, film: Fuji Velvia

I got to the south rim at the end of a clear day, just as the sun was going down. I was dumbstruck at the wonderful sight of this awesome place but I soon realised the almost impossible task of trying to capture its splendour in its entirety, so I started looking for interesting shapes among the 15-mile-wide section of the Canyon. The low sun with its warm light did a great job of making a feature of the colourful rock strata.

time of day sunset

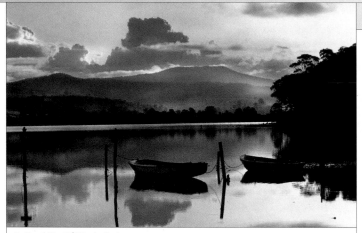

▲ Fact file 2 | Merimbula Lake at Sunset | Merimbula | New South Wales | Australia | Kirsty McLaren | It is not essential to include a big sun in your sunset shots. When the sun dips behind some clouds it often produces a delicate but warm light.

Camera tip

Slide films can be fractionally underexposed to enrich colours further. So, for example, instead of rating the film at its normal ISO 100, setting a speed of ISO 125 and then exposing at that speed effectively underexposes by one-third of a stop. Processing is done normally. How much a film can be underexposed by to give more saturated colours before the slide gets too dense depends on the individual film. Try a test roll with your normal metering technique and take shots at different ISO speeds and see which is best for your tastes.

Composition	Technique	
The 6x6cm square film format has been popular for many years even though its shape does not necessarily suit every landscape picture. I cropped this picture to emphasise the tree even more against the warmly lit and richly patterned canyon background. With big landscapes I tend to look for a potent foreground symbol to add depth and give the viewer something to rest their eyes on, and this dead tree was perfect.	The setting sun has given a lovely warmth to make the colourful rock strata of the canyon glow even more vibrant and the effect was so strong that I did not even need to use any warming filters. I took a meter reading as normal and shot several different exposures to ensure a perfect result.	

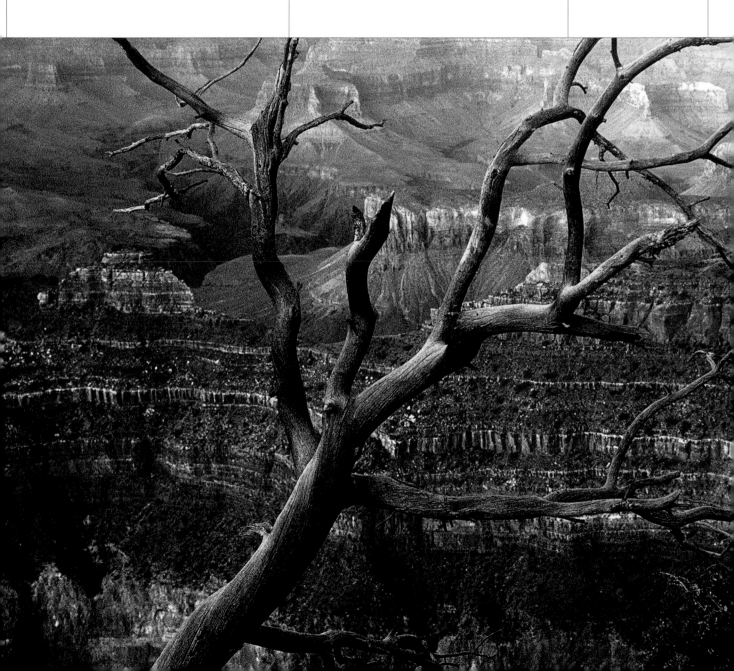

Fact file 1: Seattle Twilight

Photographer: Lynn Radeka

Location: Seattle, Washington, USA

Conditions: Taken soon after sunset

Camera: Super Cambo 5x4in, lens: 121mm, film: Kodak Ektachrome

time of day twilight

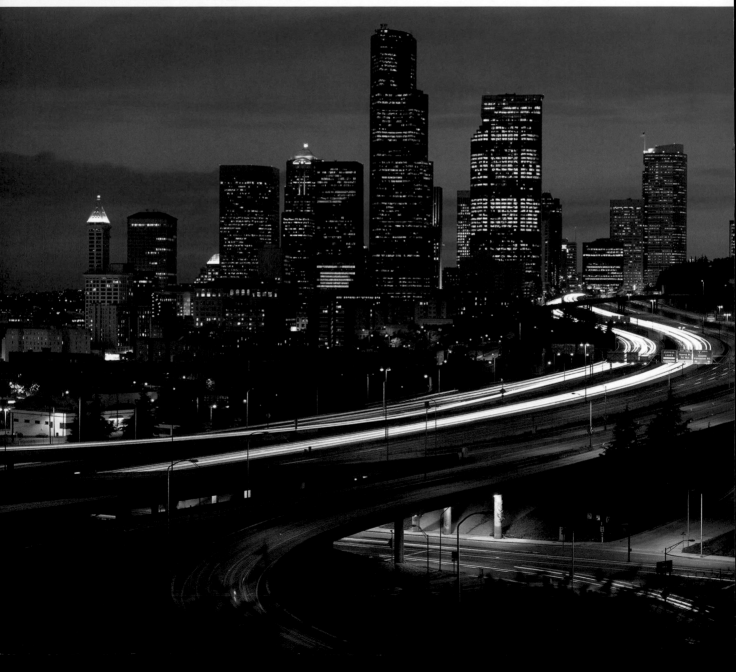

When using B (bulb) the shutter remains open for as long as the shutter release is held down. However, do not use your finger to do this because you could cause camera shake. Instead, use a locking cable release or an electronic release with a lock facility. Most modern cameras have dedicated electronic releases. This image was made on Kodak Ektachrome 5x4in film and the exposure was about 15 seconds. The long exposure contributed to the 's-curve' effect of the freeway and the car lights, which neatly lead the viewer into the city.

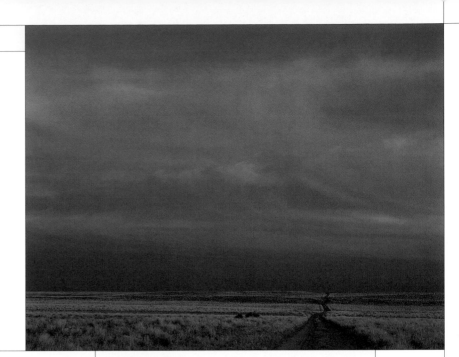

Composition

There is a beautiful sweeping 'S' in this superb urban scene which makes the composition work especially well. Furthermore, the placing of another busy road at the bottom right has avoided an over-dark area devoid of detail in this part of the picture. The intense trails of colour provided by the car lights provide a fine foundation for the city skyline. For shooting light trails, pick a busy road junction because often the more car lights the film records the better.

Colour

I took this about 30 minutes after sunset, which is my favourite time of day for shooting cityscapes. Much earlier and the lights in the windows as well as the moving car lights would not be revealed with such intensity. Much later and the sky would be black and the shadow details in the buildings would be lost resulting in an overly contrasty image.

Technique

Most cameras have a B (bulb) setting on the shutter speed dial and it is a very useful feature, allowing for many types of creative photography. The B setting simply lets you keep the camera shutter open for as long as the shutter release is kept pressed down, so exposures running into hours are possible. However, because the camera has no idea how long a B exposure could be, it is impossible to calculate exposure with the integral meter. Either take a light reading with a sensitive separate meter or set the camera to one of its timed speeds and take a reading which you can then modify and use for B photography. For instance, if you can get a reading and the meter says one second at f/2.8, this is the equivalent of two seconds at f/4, four seconds at f/5.6, eight seconds at f/8, 16 seconds at f/11, 32 seconds at f/16, and so on. Normal daylight film is fine for this sort of photography and there is no point worrying about colour casts, and the man-made lights can actually enhance the shot's atmosphere.

▲ Fact file 2 | Road at Sunset | Bisti Badlands | New Mexico | USA | Lynn Radeka | Amazing twilight colours often follow a good sunset so it is worth waiting just in case. Shoot a sequence of pictures as the colours develop and enrich.

Fact file 1: Moon over Zabriskie Point

Photographer: Lynn Radeka

Location: Zabriskie Point, Death Valley National Park, California, USA

Conditions: Taken shortly after sunrise, and moments before a cloud covered the moon

Camera: Super Cambo 5x4in on a tripod, lens: 210mm, film: Kodak Tri-X, developer: Kodak HC-110, filter: yellow

Concept	Composition
Zabriskie Point is a much-photographed area of Death Valley and my aim was to achieve a moody photograph which most tourists do not manage. On the original print, you can see subtle detail in the moon's disk. I like the visual metaphor of the lunar-like landscape as it relates to the rising moon.	There are some very powerful lines running across the picture, the main ones placed on the thirds. The moon and pointed rocky outcrop have also been placed on an upright third. A high camera viewpoint looking down slightly has given ample spatial separation between the lines of rock and there is plenty of tonal difference too.

time of day sunset

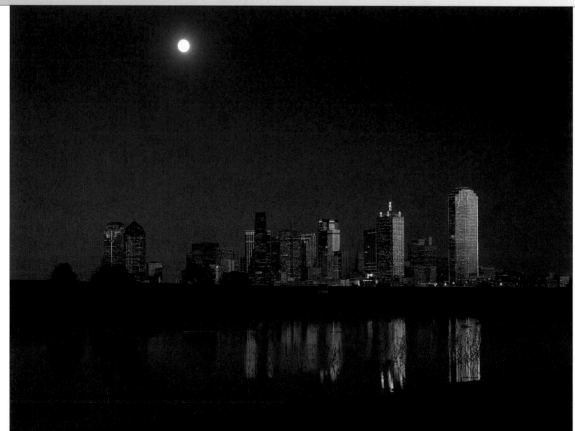

◀ **Fact file 2 | Dallas Twilight | Texas | USA | Lynn Radeka |** Soon after the sun has set there is a short twilight period when there are still vivid colours in the sky. This is a great time for skyline images when the mix of artificial and natural light can look superb.

Camera tip

The trap photographers commonly fall into when photographing a full moon is giving too much exposure so that its disk loses detail. This usually happens when the moon is against a black sky and the camera meter is misled by the amount of darkness and overexposes. A spot meter reading is advised or use the settings here as a guide for your experiments.

For a full moon

Film speed	Exposure
ISO 100	1/125sec at f/11
ISO 200	1/250sec at f/11
ISO 400	1/500sec at f/11

For a quarter phase moon

Film speed	Exposure
ISO 100	1/15sec at f/11
ISO 200	1/30sec at f/11
ISO 400	1/60sec at f/11

Technique

Early attempts at printing this image were a failure, partially because I was not certain how I wanted to express this image. It wasn't until about 12 years later that I re-examined the negative. Using some specialised printing procedures, notably contrast masks and highlight bleaching of the background mountain range, I was able to make a print that achieved my post-visualisation. Through experimentation and research in contrast masking, I have found many of these procedures invaluable in achieving the desired tonal values in my prints. Indeed, by utilising one form of masking or another, the photographer can have far greater control (from subtle to extreme) on prints than paper grade or developer changes allow.

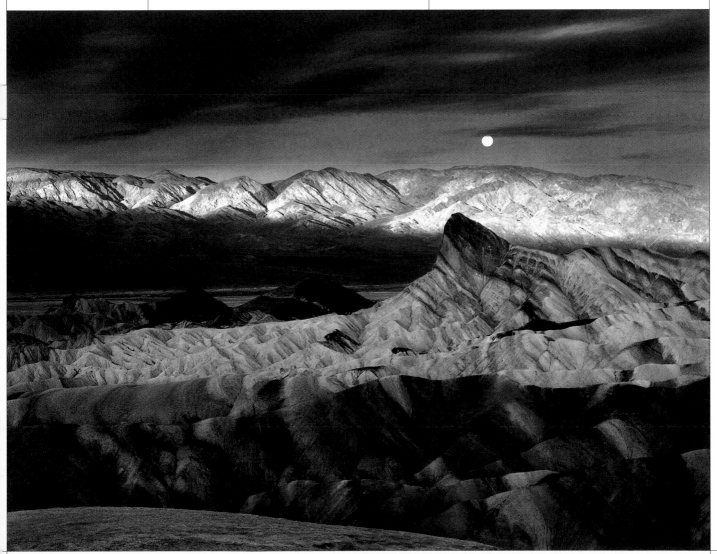

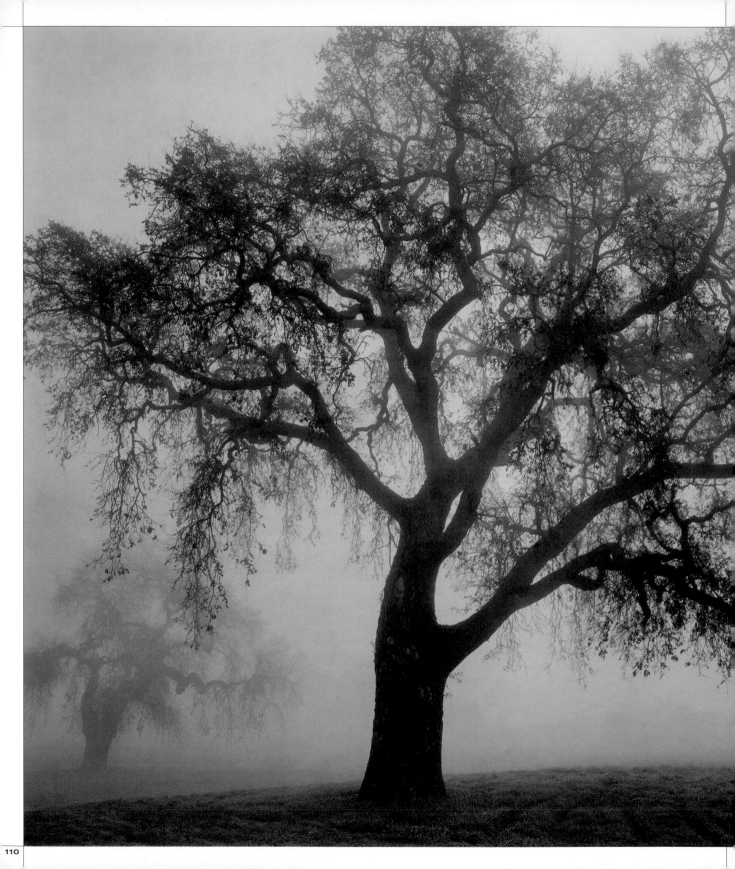

◀ Twin Trees in Fog |
Sacramento County |
California | USA | Kerik
Kouklis |

weather conditions

Fact file: Winter Morning

Photographer: Will Cheung

Location: Littondale, Yorkshire Dales, UK

Conditions: Early winter morning, very frosty, very cold. The sun had only just broken through the clouds and this meant that the conditions were altering rapidly. It is partly for this reason that no tripod was used

Camera: Nikon F-801s, lens: 200mm, film: Fujichrome Velvia, camera hand-held, no filters

weather conditions mist and fog

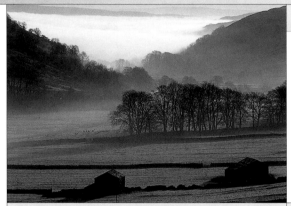

Camera tip

Fog and mist can result in condensation on your camera equipment. Protect the front of the lens with an ultraviolet or skylight filter so if there is condensation you can wipe it off the inexpensive filter rather than the expensive lens. When you leave the warm indoors take the camera out of its bag and let it gently acclimatise to the cooler temperatures. Similarly, when you go back indoors, unload the film and let any condensation that forms on the camera and lens evaporate naturally.

Colour

I love unusual weather conditions like fog and mist because they can transform the everyday into the extraordinary. Normally bright, vibrant scenes take on a low contrast, almost two-dimensional appearance in which colours are muted and subdued. It is because colours are weak or even non-existent on foggy days that the composition has to be bolder and less fussy.

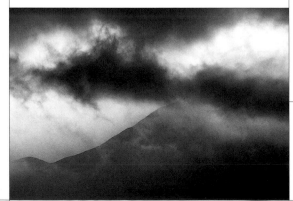

Composition

Bold shapes and strong lines work best for misty shots. Here I saw the lines formed by the drystone walls and decided to make the most of them by fitting a 200mm telephoto.

Telephoto lenses can be used to selectively isolate elements of the landscape and keep clutter in a composition to a minimum. The long lens also allowed me to compress perspective and make the various elements within a scene appear much closer together than in reality.

My first shot is shown above. The conditions were changing rapidly so I grabbed a shot as soon as I left the car. I then moved around, taking different shots as I went until I got a better viewpoint to produce the picture opposite.

◀ **Fact file 2 | Misty Mountain | Lake District | Cumbria | UK | Will Cheung |** Most times shooting landscape is a leisurely pursuit, but occasionally the conditions are so fast-moving that time is of the essence. This picture is one example when wasting time swopping filters or lenses would have meant a lost opportunity.

Technique		Camera tip
The tiny water droplets that make up fog and mist scatter light and can fool the camera meter into thinking there is more light around than there actually is. Often taking the picture using the camera's suggested exposure reading can underexpose the scene, and the fog and mist lose their airy, light-toned feel. To get round the problem either meter manually and adjust the exposure or use the camera's exposure compensation control. By how much the exposure needs to be adjusted depends on the scene and the lighting.	In dull conditions an extra half a stop should be fine but if the scene is strongly backlit, up to an extra one stop is needed to retain the mist's soft properties. For this scene I added an extra half a stop to the camera's meter reading.	With telephoto lenses use a tripod to ensure that you do not suffer from camera shake. However, this is not always possible and you might have to make do with what is available at the location. A rolled-up jacket or pullover placed on a rock or a convenient fence post to rest your camera on will give valuable stability.

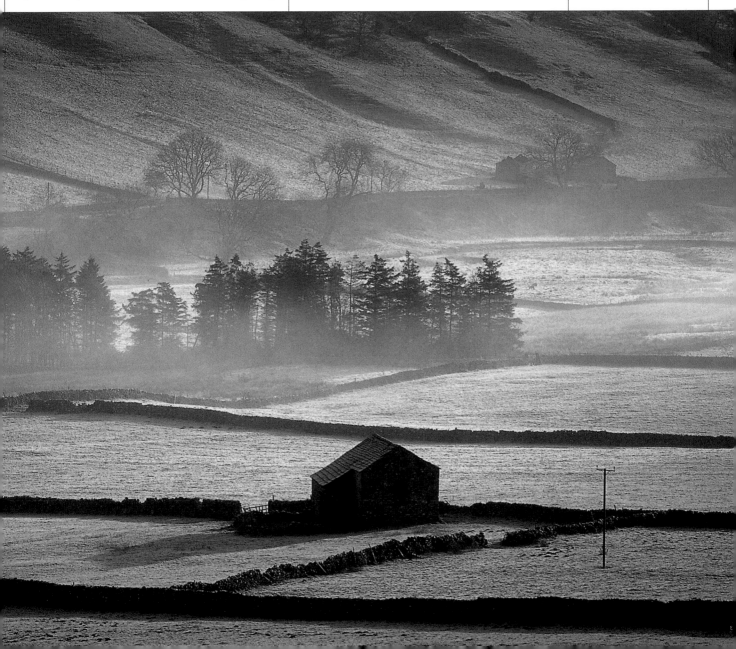

weather conditions snow

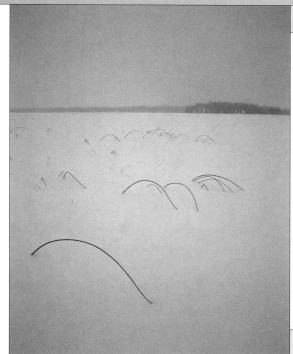

▲ Fact file 2 | Wintering Reeds | Minnesota | USA | Mark Meyer | Snow can produce exquisite pictures out of otherwise very ordinary situations. Keep your eyes open for such simple compositions.

Concept

It was unusually cold when I captured this picture in Chicago along the shores of Lake Michigan. It was late afternoon on a cloudy day and the dull light enhanced the contrast of the black trees against the pure white snow and the grey sky. I felt the grouping of the trees made an especially dramatic display of line, shape and texture. Photographing the scene I could feel the effects of an extremely cold day and I wanted to represent this moment of frozen timelessness.

Technique

Snow is a challenging exposure subject, especially when the sun is shining. Camera meters interpret scenes to record them as 18% grey reflectance so unmodified meter readings will give grey rather then white snow. Give more exposure than the meter indicates to ensure the snow remains a nice white colour. How much more depends: brightly lit snow needs at least one extra stop, maybe even two stops, while on a dull day, half or one stop is fine.

Composition

Simple compositions are frequently more effective than busy or cluttered ones and this is especially true with winter scenes. Shooting with black-and-white film rather than colour film is another way of keeping the image simple. The reduction of the scene to just black, white and a few subtle shades of grey gives graphic and eye-catching compositions.

Camera tip

Cameras can be affected by extreme cold. The shutter might stick open, the autofocus might be sluggish or the batteries might stop working. When you are not taking pictures, keep the camera in the bag or inside the front of your jacket so your body heat keeps it warm. When you are holding the camera to the eye watch out for condensation problems.

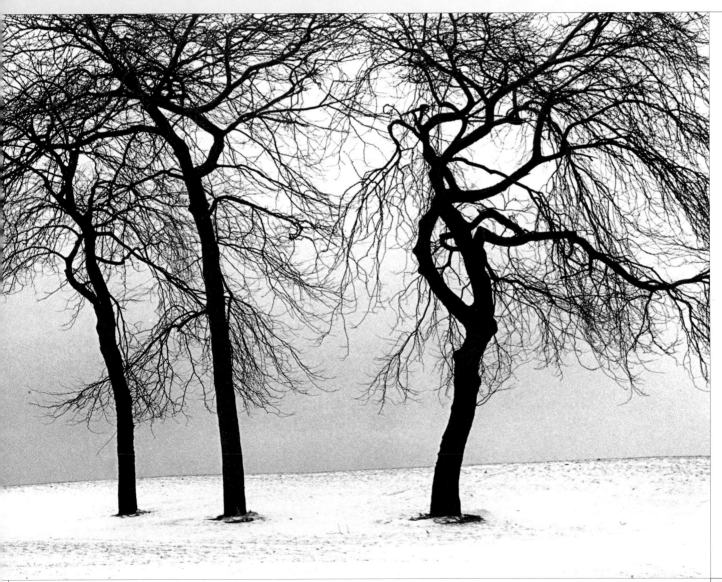

Fact file 1: Trout Creek Waterfall

Photographer: Mike Norton

Location: Kebler Pass, Gunnison National Forest, Colorado, USA

Conditions: Cloudy, late September day

Camera: 5x4in, lens: 90mm, film: Fuji Velvia, exposure: 1sec at f/45

weather conditions dull days

▲ Fact file 2 | Hodge End | Lake District | Cumbria | UK | Will Cheung | Even if the sun is shining you can easily avoid contrast and exposure problems by shooting subjects in the shade.

Camera tip

Setting slow enough shutter speeds to effectively blur water is more tricky when it is quite bright or if you have a fast film loaded in the camera. Using a neutral density filter is the solution. Neutral density (known as ND) filters are grey-coloured and are designed to absorb light without affecting the rendition of the scene on film. They are available in 2x, 4x, 8x and 16x strengths reducing light reaching the film by one, two, three and four stops respectively. In practice, using an 8x ND filter means that an exposure of 1/4 second at f/16 is possible when the light meter reading was 1/30 second at f/16. Thus, the longer exposure allows greater water blur.

Technique

Photographing flowing water is an enjoyable challenge. Some photographers like to use high shutter speeds to 'freeze' the flowing water, while others prefer to set slower shutter speeds to blur the water. Which shutter speed does this best depends on the velocity of the flowing water. With a powerful torrent even a relatively fast shutter speed of 1/125 second or 1/60 second will still give blur. At the other extreme, gently lapping water might need exposures of several minutes.

Composition

To compose with the aspen tree and the waterfall like this, I had to position my tripod in a way that my 5x4in camera was extended over the edge of the cliff. To focus, set the exposure and expose the film, I too was extended over the edge of the cliff, balancing on one foot so that I could take a spot meter reading off the aspen leaves.

Colour

Bright sunshine might sound the perfect lighting for landscapes but it can cause problems too. The high contrast produced by a strong sun can mean delicate hues will be lost and even the use of a polarising filter to reduce glare will not help.

In this scene, where there is flowing water the soft lighting from the cloudy day was essential to maintain detail in the water and keep contrast down. Also, because of the cloudy day I was able to take photographs way past early morning and this image was made at 11.30am.

◀ Fact file 3 | Zion National Park | Utah | USA | Christophe Cassegrain | Dull days are absolutely perfect for superb detail shots like this, but blurred water has a tendency to go too blue. To avoid this fit an 81B warm-up filter.

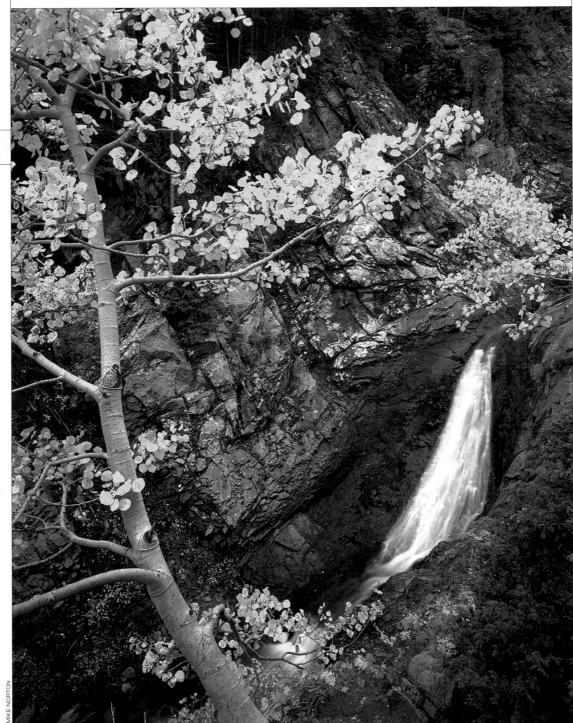

© MIKE NORTON

Fact file 1: Sea and Slate

Photographer: Peter Clark

Location: Friog, North Wales, UK

Conditions: June but with a force 8 gale blowing in off the sea

Camera: Canon EOS 1, lens: 24mm, film: Ilford Pan F rated at ISO 25, filters: 8x red and polariser acting as a neutral density, exposure: around 30secs at f/32, which included an extra one stop for reciprocity law failure, developer: Ilford Perceptol 1+1, paper: Ilford Multigrade at grade 4½

Concept

The white veins of quartz set in the almost black slate cried out to be photographed and provided the ideal lead-in and foreground interest for a shot of the angry sea set against the dark mass of the town on the other side of the bay. The use of a very long exposure captured the sea's flow over the slate.

weather conditions stormy days

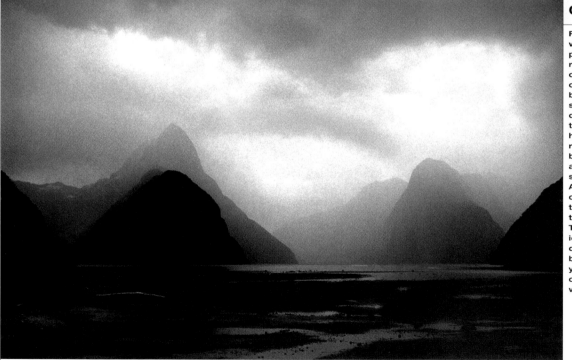

▲ Fact file 2 | Milford Sound Fjord | South Island | New Zealand | Matheson Beaumont | Black and white is the perfect medium in stormy conditions and often gives a more powerful mood than similar shots taken in colour.

Camera tip

For coping with inclement weather, keep a large polythene bag, a few rubber bands and a chamois leather in your camera bag. The bag can be fashioned into a showerproof housing quickly by cutting a hole for the lens to poke through held in place with the rubber bands. You should be able to use the camera and keep it fairly dry at the same time.
Also put an ultraviolet (UV) or skylight filter on the lens to stop water landing on the sensitive front surface. The chamois leather is ideal for mopping up and drying your kit afterwards but if you get a large piece you can drape this over the camera as protection from water and dust.

Composition

There are three distinct areas of tone here and each confirms nicely to the rule of thirds. The foreground slate dominates the foreground and the lines of quartz lead the eye diagonally into the picture. That rocky outcrop on the right then prevents the eye exiting the image and the brightness of the sea takes over to keep your interest. Finally, a heavy, brooding sky finishes off a stunning composition.

Technique

Every film has an optimum exposure range. For a typical daylight-balanced film, this could be one second to 1/10,000 second. Beyond this and the film loses effective speed. This effect is known as reciprocity law failure. It can be compensated for by increasing the amount of exposure you give.

With the small lens aperture and the combination of a red filter with a polariser filter used for this picture, the calculated exposure time of 15 seconds was doubled to compensate for any reciprocity law failure.

The buffeting wind was so powerful that I had to hold the tripod down to stop the camera toppling over. Consequently, bearing in mind the extremely long exposure, several shots were not sharp enough.

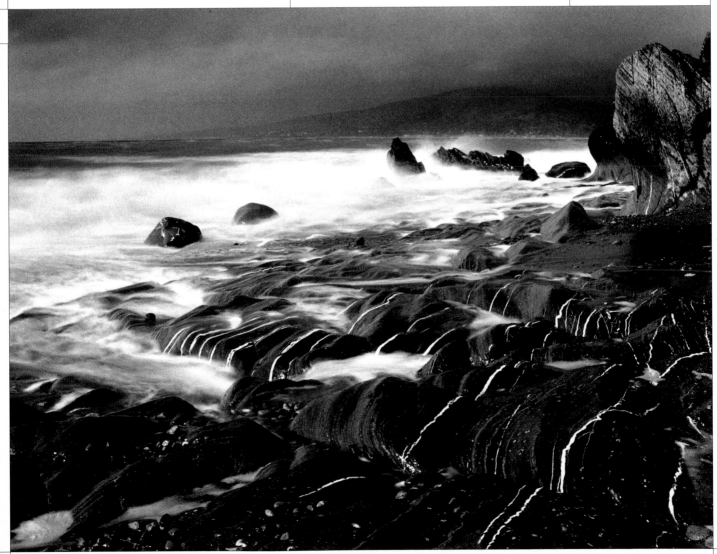

Fact file 1: Rainbow at Tufu Point

Photographer: Tom Till

Location: Rainbow at Tufu Point, Ta'u Island in American Samoa National Park, South Pacific Ocean

Conditions: Stormy and wet

Camera: Toyo 5x4in Field II on a tripod, lens: 90mm, film: Fuji Velvia, exposure: 2secs at f/45, filter: Tiffen warm polariser

weather conditions shooting rainbows

Composition

A very wide-angle lens is needed to photograph a full rainbow but effective photographs can also be made using telephoto lenses to shoot just a segment of it. Personally, I always like to have the rainbow as part of the overall picture. Here I placed some foreground at the bottom of the composition to add scale and interest.

Technique

Photographing rainbows is difficult because they are often ephemeral which means I always work as fast as possible. I usually use an umbrella to protect the camera from any rain. In this case, it was also very windy which made shooting with a 5x4in camera even more difficult.

For exposure, I metered on the foreground looking for a grey tone, then I used a two-stop neutral density filter to even out the contrast between the sky and the land.

Colour

After spending years in the field watching weather, I have grown quite adept at predicting rainbows which occur early or late in the day. Rainbows appear in an arc directly opposite the sun and will be more complete as it gets closer to sunrise or sunset. I often use a polariser filter to intensify the rainbow's colours and a neutral density graduate to control contrast between the sky and the foreground.

Camera tip

Overexposing a rainbow scene will result in it looking anemic so it pays to err on the side of underexposure. A spot meter reading direct from a bright part of the rainbow will ensure its colours come out nicely saturated. A polariser filter will intensify the rainbow and make it stand out more prominently from the sky behind. Rotate the polariser in its mount and study the effect in the viewfinder until the colours are at their richest.

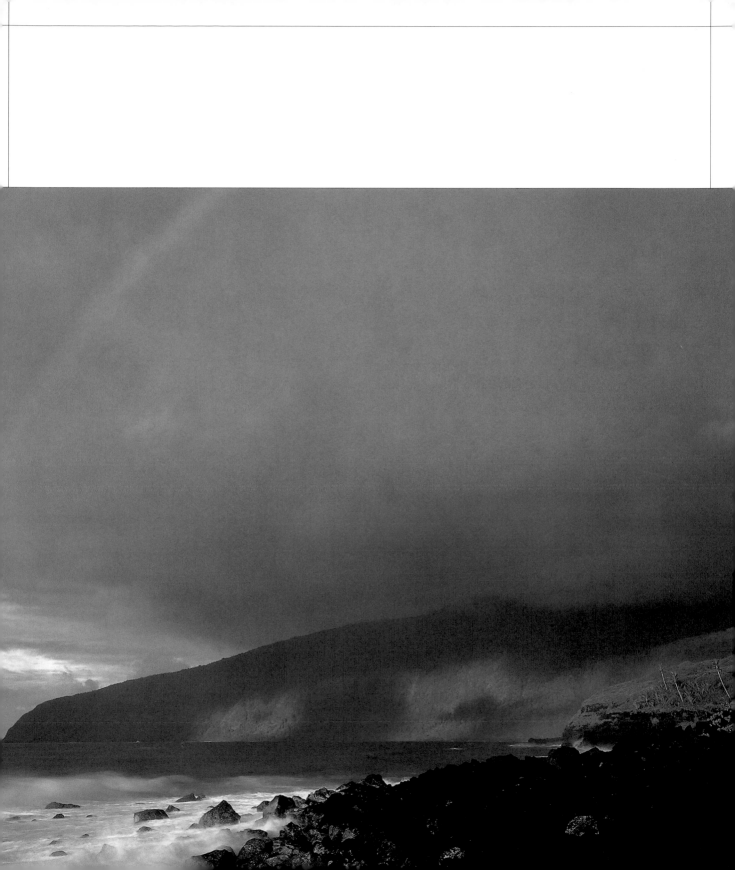

Camera tip

Rainbows and water go hand in hand and if your camera gets wet, it is important to dry it out properly before storing it away. When you get home, mop off any excess moisture and unload the film. Then open the back, remove the lens and place your gear somewhere warm so that it can dry naturally and gradually.

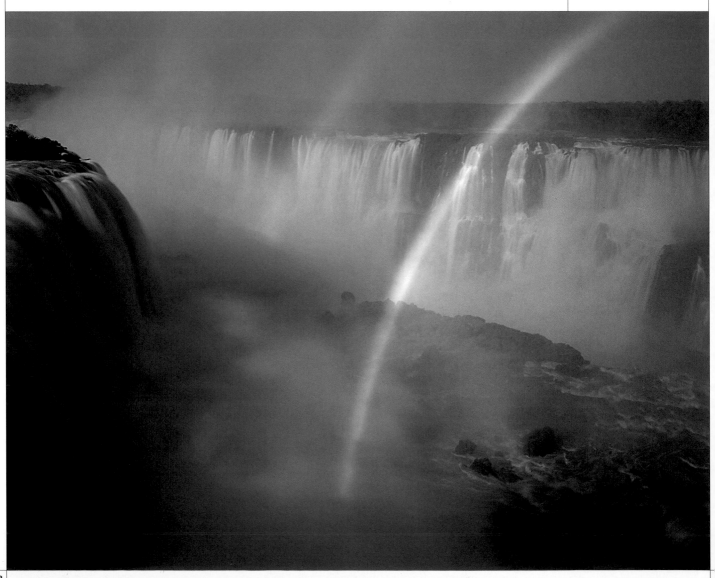

▶ **Fact file 2** | **Foot of Moelfre** | near Dyffryn Ardudwy | west coast of North Wales | UK | Dave Newbould | Pictures featuring just the rainbow lack scale and can be quite dull. Compositions featuring bold foreground detail will enliven images.

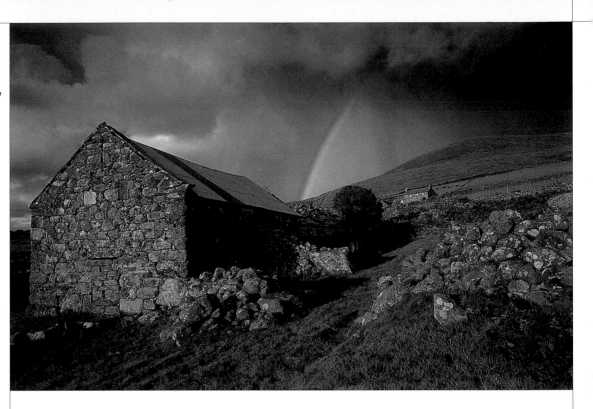

◀ **Fact file 3** | **Iguazú Falls** | Brazil-Argentina border | Tom Till | Waterfalls which throw up a lot of spray are prime sites for rainbows. Of course, the sun has to be out and this can cause contrast and metering problems. Bracketing exposures around your meter reading will ensure a perfect result.

▶ **Fact file 4** | **Nevis Bluff** | South Island | New Zealand | Matheson Beaumont | Of course, a huge part of successful rainbow pictures is being there in the first place. Rainbows are not predictable phenomena and you have to make the most of them as and when they appear. Bright showery days are often conducive to rainbows so watch the local weather forecast for such conditions.

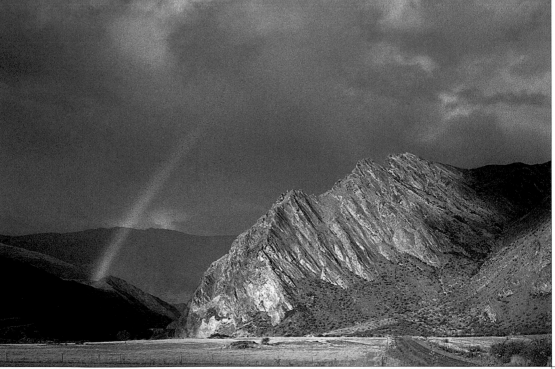

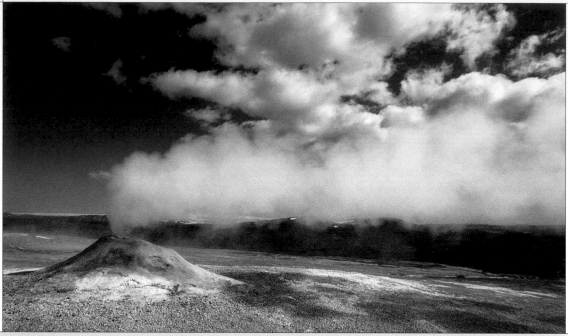

give more or less exposure than the given reading.

Exposure lock
Very useful camera feature that lets you take a meter reading, memorise it and then recompose.

Exposure meter
Device to take light readings for determining correct exposures. All modern cameras have an exposure meter built in but separate hand-held meters are also available.

Exposure modes
Program AE: An automatic exposure mode where the camera sets aperture and shutter speed according to the light levels.

Aperture-priority AE: An auto mode where the user sets the aperture and the camera sets the appropriate shutter speed.

Shutter priority AE: Another auto mode but this time the

glossary

Jargon and technical terms used in this book.

▲ Hveravellir Hot Springs | Iceland | Hans van der Pol | Filters can improve already exciting scenes. In this instance, a polarising filter was used to enhance sky detail.

Automatic exposure
Most cameras have autoexposure even though many photographers prefer to meter manually. Autoexposure is available via various modes. See Exposure modes.

Autofocus
Most 35mm SLR cameras are now autofocus and this technology is also entering the world of the medium-format camera. Autofocus is quick and can save time but it is not infallible so you should be prepared to override the camera and focus manually – for example, in low contrast situations or when there is nothing for the system to latch on to.

Autofocus lock
Almost all autofocus SLRs have this feature. Partial pressure on the shutter release makes the camera focus and by keeping the pressure on, you can now recompose without the camera adjusting focus. Very useful if the subject is difficult to focus on. Just focus on something at a similar distance and use focus lock before recomposing.

Cable (or remote) release
A simple device that screws into the camera from which you can fire the shutter to take the shot. A very useful gadget for long shutter speed work because it lets you take shots without you touching the camera.

Camera types
There are many types available in a whole range of different formats.

Advanced Photo System (APS): The most recent film system producing negatives measuring 30x17mm.

35mm format: Format has been around for decades and gives negatives measuring 36x24mm – probably the world's most used film format. Cameras of this type are quick to use, versatile and packed with technology for ease of use.

Medium-format: Cameras use 120 or 220 roll-film giving images of 6x4.5cm, 6x6cm, 6x7cm, 6x8cm or 6x9cm depending on the actual camera. For landscape, the first three named are very popular.

Large-format: Cameras that are said to be large-format use sheets of film; 5x4inch is popular, so too is 10x8in. Large-format cameras are big and slow to use but the quality they produce is superb and there is the option of using camera movements which can correct for converging verticals.

Centre-weighted meter
An exposure meter with a greater emphasis on the central area of the image. Many meters work on this basis even those which have multiple zone meters.

Colour temperature
All light has a colour temperature. Typical noon sunlight – which is what daylight films are balanced for – is 5500Kelvin. The lower the figure the more orange the light, and the higher the figure the bluer the light. Blue sky can be around 12,000K while the orange light at sunset is around 4000K or lower.

Depth-of-field
Depth-of-field is the amount of front-to-back sharpness in a scene. It is affected by aperture choice, camera to subject distance and lens focal length.

Exposure bracketing
A technique used to ensure a perfect result, used particularly in extreme lighting. It means to shoot extra exposures at below and above the camera's suggested reading.

Exposure compensation
Most cameras have this feature, usually plus or minus two stops in half or one-third stop steps. It lets the user set the camera to

user chooses the shutter speed leaving the camera to set the aperture.

Manual metering: Both aperture and shutter speed are set by the user, based on readings taken with the camera's meter or a separate hand-held one.

Film speed
Every film has a speed, quoted as an ISO number. The lower the number the less sensitive and the slower the film; the higher the number the faster the film. From ISO 50 to 3200. ISO 50 is called a slow film while those within the ISO 100–200 range are dubbed medium speed films. At ISO 400 we enter the realm of the fast film and by ISO 1600 we are into ultra-fast territory.

Filters
Pieces of high-quality glass or optical resin which are held in front (usually) of the lens in a mount or special holder to modify the light reaching the film. Many filter types are available and all sorts of effects are possible.

Graduate filters
These filters are toned one half and clear the other with a gradual transition from one area to the next. The strength and colour of the tone varies but the most popular among landscapers is neutral

density (or grey) graduates. These help to control the contrast range between the dark foreground and the bright sky, and used correctly can let you record tone in both areas of the picture.

Incident light reading
Done with a separate light meter with a diffuser dome over the metering sensor. Measures light falling on to the subject rather than the light being reflected from it. Useful, for example, in snow where the whiteness can cause underexposure unless extra exposure is set.

Lenses
Fisheyes: Give uncorrected images where straight lines away from the centre of the frame are curved.

Wide-angles: Anything with a focal length shorter than the format's standard focal length. In the 35mm format, the 28mm focal length is the most popular while lenses like a 17mm or 20mm are known as ultra wide-angle lenses.

Standard: The scientific definition of a standard lens is equivalent to the diagonal of the film frame. In the 35mm format that is 42mm but the accepted standard focal length is 50mm, which gives an angle of view roughly equating with that of the human eye.

Telephotos: Any lens with a focal length longer than a standard lens is known as a telephoto. A 100mm or 135mm lens is known as a medium telephoto while a 300mm lens is known as a long telephoto.

Macro: A lens that lets you focus really close giving half (1:2) or life-size (1:1) magnification of a subject. Macro lenses are specially corrected to give their optimum performance at close distances, unlike other lenses which are computed to work best at infinity.

Lens hood or shade
Used to prevent stray light striking the front of the lens and causing flare. Extending hoods are expensive but they suit zoom lenses.

Polariser filter
Look through this filter and it appears neutral grey, but in use it can strengthen a weak blue sky, subdue reflections from glass or water and increase colour saturation by eliminating glare. It is a very useful filter for the landscaper.

Reflected light reading
All camera meters take this type of meter reading, measuring light being reflected from the subject. Can be fooled by very bright or very dark subjects.

Spot meter
Lets you take light readings from specific parts of the scene. The area the meter is measuring from is usually indicated in the viewfinder.

Tripod
Three-legged gadget to support the camera. Come in all sorts of styles and sizes, from mini table-top pods upwards. Stability is important so buy the best you can afford. The latest tripods are carbon-fibre construction, which are expensive but very lightweight and stable.

▼ Hveravellir Hot Springs | Iceland | Hans van der Pol | A tripod is a much underrated camera accessory yet one of these three-legged gadgets will undoubtedly help you in your quest for great landscape images.

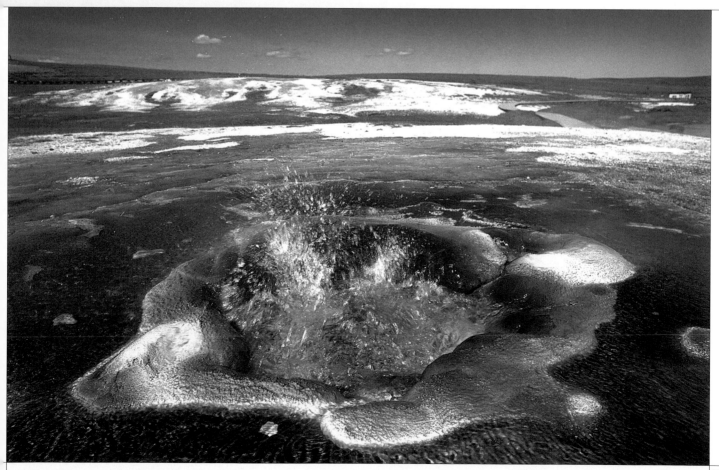

▼ Rugged Falls | Adams
Canyon | Wasatch Mountains
| Northern Utah | USA |
Jay Nielsen |

photographers

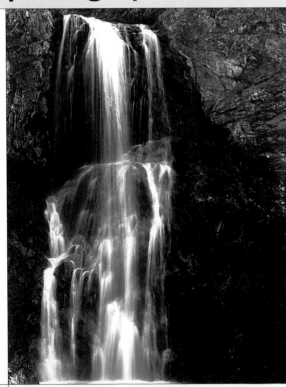

▶ Reeds, Water | Spring Valley Lake | Warren County | Ohio | Ken Schory | Apparently dull scenes can make for lovely landscape images and all you have to do is to visualise them in the first place. With the help of the advice and the inspiring images in this book, you are now equipped to shoot great images yourself. Good luck.

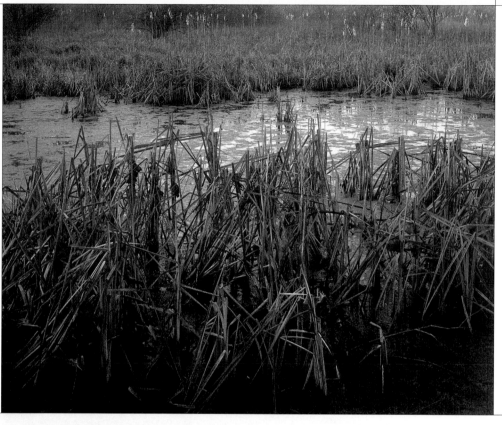

▼ Filtered Sunlight |
Farmington Canyon |
Wasatch Mountains |
Northern Utah | USA |
Jay Nielsen |

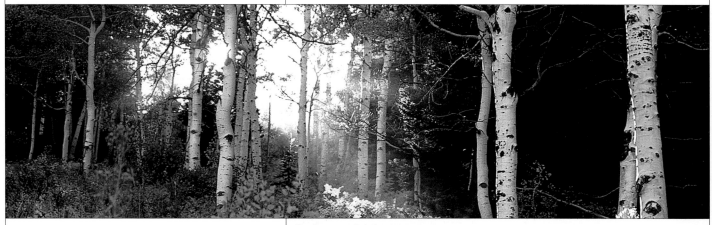

Acknowledgements

A great number of people have been responsible for supporting me in the writing and production of this book. So thanks to all the photographers for their expertise, patience and, most of all, for taking their stunning images in the first place. Long may they continue producing great images.

Brian Morris for inventing the Camera Craft concept and commissioning me in the first place.

Kate Stephens for editing and designing the book as well as keeping me enthused.

Sarah Jameson for finding many of the pictures you have enjoyed here.

And finally, thanks to my mum and dad, without whom nothing would have been possible.

William Cheung